THE WASTE LAND

and other poems

THE WASTE LAND

and other poems

T.S. Eliot

a *Broadview Anthology of British Literature* edition

General Editors,
The Broadview Anthology of British Literature:
Joseph Black, University of Massachusetts
Leonard Conolly, Trent University
Kate Flint, Rutgers University
Isobel Grundy, University of Alberta
Don LePan, Broadview Press
Roy Liuzza, University of Tennessee
Jerome J. McGann, University of Virginia
Anne Lake Prescott, Barnard College
Barry V. Qualls, Rutgers University
Claire Waters, University of California, Davis

broadview press

Library and Archives Canada Cataloguing in Publication

Eliot, T. S. (Thomas Stearns), 1888-1965
 The waste land and other poems / T.S. Eliot.

(A Broadview anthology of British literature edition)
Includes bibliographical references.
ISBN 978-1-55111-968-7

 1. Eliot, T. S. (Thomas Stearns), 1888-1965—Criticism and interpretation.
I. Title. II. Series: Broadview anthology of British literature

PS3509.L43A6 2010 821'.912 C2010-906966-8

Broadview Press is an independent, international publishing house, incorporated in 1985.

We welcome comments and suggestions regarding any aspect of our publications—please feel free to contact us at the addresses below or at broadview@broadviewpress.com.

North America PO Box 1243, Peterborough, Ontario, Canada K9J 7H5
 2215 Kenmore Ave., Buffalo, New York, USA 14207
 Tel: (705) 743-8990; Fax: (705) 743-8353
 email: customerservice@broadviewpress.com

UK, Europe, Central Asia, Eurospan Group, 3 Henrietta St., London WC2E 8LU, UK
Middle East, Africa, India, Tel: 44 (0) 1767 604972; Fax: 44 (0) 1767 601640
and Southeast Asia email: eurospan@turpin-distribution.com

Australia and New Zealand NewSouth Books, c/o TL Distribution
 15-23 Helles Ave., Moorebank, NSW, Australia 2170
 Tel: (02) 8778 9999; Fax: (02) 8778 9944
 email: orders@tldistribution.com.au

www.broadviewpress.com

Broadview Press acknowledges the financial support of the Government of Canada through the Canada Book Fund for our publishing activities.

Developmental editors: Laura Buzzard, Laura Cardiff, Jennifer McCue

This book is printed on paper containing 100% post-consumer fibre.

PERMANENT 100% Ancient Forest Friendly™

PRINTED IN CANADA

Contents

Introduction

The poetry and prose of T.S. Eliot probably did more than that of any other writer to transform the face of twentieth-century English writing. His Modernist poems of the 1910s and 1920s (*The Waste Land* chief among them) were revolutionary both in their form and in their content—yet Eliot himself, the most unlikely of revolutionaries, became an icon of the literary establishment. He voiced in unique fashion the bleakness and despair that was characteristically felt by many in the early twentieth century—yet he became a leading voice of traditional Christianity. He embraced difficulty as the literary strategy most consonant with the character of his era—yet he also wrote a succession of highly accessible plays for the popular stage. He strove for Christian virtue, but has been strongly criticized for alleged hostility towards women and towards Jews. In short, he is a central figure of the twentieth century not only because his works are central documents of its literature, but also because they embody many of the paradoxes of the age.

Thomas Stearns Eliot was born in St. Louis, Missouri, in 1888, the youngest son in a distinguished New England family that traced its roots back to the first Puritan settlers of Massachusetts. Eliot followed his older brother to Harvard in 1906, where he joined the board of Harvard's literary magazine and started a lifelong friendship with Conrad Aiken, a fellow board member. In 1909, the year before he completed his M.A., Eliot began drafting the poems that would become "The Love Song of J. Alfred Prufrock," "Preludes," "Portrait of a Lady," and "Rhapsody on a Windy Night." He spent a postgraduate year at the Sorbonne in Paris and then began doctoral studies in philosophy at Harvard. His dissertation was on the ideas of the then-influential French philosopher Henri Bergson, whose emphasis on the intuitive and subjective aspects of reality and on the importance of change may have influenced Eliot's poetic explorations of the human psyche. Certainly a strong awareness of the subjectivity of

perception, of the importance of the unconscious, and of alienation and social claustrophobia in an unpredictably changing world are all powerful elements in Eliot's early poetry.

While both Eliot and Aiken were in London in 1914, Aiken showed the manuscript of "Prufrock" to American poet and critic Ezra Pound (then living abroad), who immediately recognized it as extraordinary work. The alliance of Pound and Eliot marked the beginning not only of Eliot's career as a poet (Pound and his wife financed the publication of *Prufrock and Other Observations*), but of a literary collaboration that profoundly influenced the development of modern literature.

"The Love Song of J. Alfred Prufrock," as critic James F. Knapp said, changed "our conception of what kind of shape a poem might take." With little connecting or transitional material, the poem juxtaposes disparate thoughts and scenes and combines classical literary references with images of urban, industrial twentieth-century life. With strong rhythms that blend formal and informal speech and striking metaphors, Eliot creates an ironic love song in the frustrated inner voice of "Prufrock"'s central figure, who, in the face of his bleak physical and spiritual life, is unable to act on his love.

Inspired by what he referred to as "the mind of Europe," and with some persuasion by Pound, Eliot chose England as his permanent home. His decision was solidified by an impulsive decision in 1915 to marry Vivienne Haigh-Wood, an Englishwoman whom he had met that spring. In England, Eliot balanced writing and editorial work for the avant-garde magazine *The Egoist* with more reliable employment as a schoolteacher and then as a bank clerk at Lloyd's Bank in London.

Eliot's first book of criticism, *The Sacred Wood* (1920), established him as a discerning and erudite literary critic and introduced a new set of critical precepts that would become highly influential. Eliot placed a high value on "impersonality" in poetry, and on the idea of an "objective correlative" as a means of expressing emotion through a set of objects, circumstances, or chain of events. Eliot's introduction of these ideas to the literary world helped pave the way for the critical approach known as "New Criticism." In the writings of I.A. Richards and others of this school, the focus was on the work itself as an artefact independent of authorial intention. Eliot's essays also examined

his sense of the necessary difficulty of modern writing, which he believed had the nearly impossible task of synthesizing the seemingly unrelated, chaotic experiences of modern citizens.

By 1921, affected by the strain of overwork and the increasing pressure of his wife's failing physical and mental health, Eliot had a nervous breakdown. During a three-month-long rest cure, he was finally able to complete *The Waste Land*, a project he had begun in 1914. Originally composed as a series of narrative poems, *The Waste Land* was considerably longer in its original version; Pound helped Eliot pare down and fuse the diverse materials into a rhythmically coherent whole. Published in 1922, *The Waste Land* deviated far more decisively than had "Prufrock" from accepted notions of what constituted poetry. Written in fragmented form, this poem of complex imagery, multiple voices, jazz rhythms, and dense literary and mythological allusions jumps between perspectives and scenes without connective or transitional passages. With its radical break from established conventions in structure, theme, and expression, and its blending of western and of non-western ideologies, *The Waste Land* can be disorienting for readers—so much so, in fact, that when the poem first appeared some writers and critics wondered if the poem was a hoax orchestrated by Eliot and his literary friends.

Much as *The Waste Land* was derided in some quarters, in others it established Eliot as a groundbreaking writer. Meanwhile, his critical writing in the international literary journal *The Criterion* (which Eliot founded in 1922) helped to round out his reputation as one of London's leading literary figures. In 1925, Eliot was recruited by the publishing firm Faber and Gwyer (later Faber and Faber) as a literary editor and board member. The position, which he held for many years, further extended Eliot's influence, as he was able to cultivate young writers—such as W.H. Auden—whose work he found promising.

Eliot's next long poem, *The Hollow Men* (1925), in some ways extended *The Waste Land*'s articulation of alienation and despair, but it also dealt with more transcendent themes of what Eliot called "the salvation of the soul." Eliot's Christian faith continued to strengthen, and in 1927, the same year he was naturalized as a British citizen, Eliot was baptized into the Church of England. Religion thereafter became the focus of his life, and in 1933 he moved

to Glenville Place presbytery, where he served as a church warden for seven years. There he wrote a series of poetic meditations on religious themes and scenarios, including *Journey of the Magi* (1927) and *Marina* (1930). Steeped in Eliot's studies of Shakespeare and Dante, these works meditate on spiritual growth while experimenting with more traditional dramatic forms. The dramatic monologue form in which *Journey of the Magi* is constructed, for example, is reminiscent of Robert Browning's work.

Much of Eliot's later career focused on dramatic writing. For many years he worked on *Sweeney Agonistes*, an unfinished experimental play of modern life, written in rhythmic prose accented by drum beats. He then published two ecclesiastical dramas, one of which was *Murder in the Cathedral* (1935), a ritual drama based on the murder of Thomas à Becket, before turning to clever West End social dramas like *The Cocktail Party* (1950). Though innovative in their attempts to reconcile classical drama with modern themes, these plays have not been successfully revived in recent decades. Ironically, however, a book of playful children's verse that Eliot wrote for his godchildren, *Old Possum's Book of Practical Cats* (1939), has been much more successful on the stage than any of Eliot's plays; it was adapted by British composer Andrew Lloyd Webber into the hit musical *Cats* (1980).

Despite a busy lecturing schedule and a marriage that was increasingly taxing (Vivienne was institutionalized in 1938), Eliot produced four long poems in the late 1930s and early 1940s that together, published as *Four Quartets* (1943), he considered his crowning achievement. Comprising "Burnt Norton," "The Dry Salvages," "East Coker," and "Little Gidding," *Four Quartets* was in part inspired by the later string quartets of Beethoven. With its powerfully suggestive imagery and elaborate patterns of sound, it is among Eliot's most complex and technically masterful works. It also gives voice to Eliot's conviction that, in a world otherwise devoid of meaning, submission to God is essential. *Four Quartets* for a time took pride of place over *The Waste Land* as Eliot's most celebrated work.

The late years of Eliot's life were filled with personal happiness and public recognition of his contribution to modern literature. He was awarded eighteen honorary degrees, and in 1948 he was awarded both a Nobel Prize for Literature and the British Order of Merit. Vivienne having died in 1947, in 1957 Eliot married Valerie Fletcher

and enjoyed what he described as the only happy period of his life since childhood. He died in London in 1965 and was buried, according to his wishes, in his ancestors' parish church at East Coker. The plaque on the church wall bears his chosen epitaph, from *Four Quartets*: "In my beginning is my end, in my end is my beginning."

Near the end of his life Eliot commented, with sly irony, that he would "perhaps have a certain historical place in the literary history of our period." And indeed, he was lauded on his death as a unique literary figure; his obituary in *Life* magazine declared that "our age beyond any doubt has been, and will continue to be, the Age of Eliot." In subsequent decades the praise has been less effusive, and in two respects Eliot's work has been sharply criticized: most critics now acknowledge elements of misogyny and of anti-Semitism in his writing. But the impact of his poetic innovation is lasting, and a sense of the centrality of Eliot's work to the literary history of the twentieth century has remained constant. As Northrop Frye observed, "Whether he is liked or disliked is of no importance, but he must be read."

The poems included here are from Eliot's first three published volumes; together they represent Eliot's poetic development from 1909, when the earliest poems in *Prufrock and Other Observations* were begun, to 1922, when *The Waste Land* was published. At the beginning of this period Eliot was unknown to all but a few literary and philosophical thinkers; by its end, his status as a key modernist writer and thinker was indisputable.

When *Prufrock and Other Observations* was published by Egoist Press in 1917, readers were first exposed to Eliot's disjointed poetic style, his sharp portraits of the subtleties of the unconscious, and his characters' angst and hopelessness as they search for meaning in a bewildering world. For some, the narrative style of these poems (and their density of allusion) was reminiscent of Robert Browning's dramatic monologues—and poems such as "The Love Song of J. Alfred Prufrock" and "Portrait of a Lady" may indeed be classed as dramatic monologues. But as with so much else, Eliot approached that genre with a perspective new to English poetry; his speakers are seen only from a distance and rarely reveal anything concrete about themselves. More broadly, the poems in the volume tend to lack any clearly defined perspective and to move abruptly from one topic to the next, or

from one character's thoughts to another's. In stylistic and structural elements such as these Eliot drew much of his inspiration from the French Symbolist poets—Paul Verlaine, Charles Baudelaire, and perhaps most particularly Jules Laforgue, whose poetry of alienation is strongly echoed in "The Love Song of J. Alfred Prufrock" and "Portrait of a Lady," both completed after Eliot's return to Harvard in 1911. The latter poem, most obviously in its title, also pays homage to novelist Henry James, whose influence can be seen throughout this collection. It is James who can be credited with influencing Eliot's portraits of characters suffocating within the confines of respectable society—a society whose unspoken rules they cannot, or dare not, offend.

In 1919, in the early years of their Hogarth Press, Leonard and Virginia Woolf issued a small collection entitled *Poems by T.S. Eliot*. The seven pieces in this collection comprised part of Eliot's next major volume, *Poems*, which was published in New York in 1920 (a book with nearly identical contents, *Ara Vos Prec*, was published in London the same year). With these poems Eliot embraced more fully the ideal of difficulty in poetry, which he believed was required in order to reflect the fragmented nature of modern existence. The poems lack any cohesive narrative or traceable storyline; meaning is elusive, and the language is concentrated and dense with allusions to Jacobean drama, to Henry Adams, to the New Testament, to French poetry, and to much else. Epigraphs contain unidentified quotations. Abrupt transitions in topic and perspective disorient readers, and the poems' settings range across Europe, with four poems written entirely in French. As in *Prufrock*, we find enigmatic speakers searching for meaning in a world that seems to resist any unity of interpretation. And more so than in the earlier collection, madness lurks in the margins, threatening to overwhelm at any moment.

In *Poems*, we encounter many elements that will reappear in Eliot's subsequent work. For example, Eliot originally wanted to use "Gerontion" as a preface to *The Waste Land* (he was dissuaded by Pound), which suggests that Eliot himself saw thematic and stylistic connections between the pieces. "La Figlia che Piange" narrates a scene that becomes key in *The Waste Land*, where it reappears as the recollections of the "'hyacinth girl.'" In three of the included poems we meet Sweeney, a character who later reappears as the protagonist of *Sweeney Agonistes*. The troubling anti-Semitism that is most

blatant in "Burbank" and "Gerontion" can also be seen in some of Eliot's later work, particularly in his prose and in *Sweeney Agonistes*'s Jewish characters.

The Waste Land was first published in the inaugural issue of Eliot's own London magazine, *The Criterion*, in October 1922. It confronted readers with a culmination of the sense of disillusionment seen in *Prufrock* and *Poems*, capturing the breakdown of European culture—and perhaps a hint of a personal breakdown as well. In this work, we find Eliot's penchant for allusion taken to a new level. The difficulty of the poem's tangle of references is compounded by copious and often cryptic endnotes (which were not included in the *Criterion* publication of the poem; Eliot claimed they were written in order to add enough length to justify the poem's independent publication in a book edition).

The title and framework of Eliot's groundbreaking poem were substantially influenced by Jessie Weston's *From Ritual to Romance* (1920), which details the various legends of the Holy Grail and explores the influence of pre-Christian religions on these legends. According to most accounts of the Grail, the sacred vessel lies in the heart of a (formerly fertile) Waste Land that is now stricken with drought and presided over by a Fisher King who is cursed with impotence. The land and its king can be saved from permanent sterility only by a knight who is able to pass several tests and attain the Grail, thus bringing about regeneration. Overlaying this myth with a modern setting and numerous cultural references, Eliot shows that a similar sterility plagues a contemporary society characterized by casual sexuality, blatant materialism, and the industrial exploitation of nature. His own experiences and observations drive many of the poem's dramatic vignettes.

With its disparate images, ever-shifting narrative events, and seemingly random structure, *The Waste Land* embraces the fragmented present while looking back to a more coherent past. Allusions to seventeenth-century poets, to Chaucer, to Shakespeare, to Dante, to pre-Socratic philosophers, and to works of history and anthropology, such as James Frazer's twelve-volume anthropological study *The Golden Bough* (1890–1915), gesture towards the presence of a recurring order beneath contemporary history and indicate the possibility of regeneration. The poem's disconnected and highly allusive character

provoked charges of intentional obscurity upon the poem's publication, but, as Eliot maintains in his essay "The Metaphysical Poets," any poetry developed out of a complex and various society must itself be various and complex.

By its very nature, *The Waste Land* seems to resist order and any cohesive account of meaning; its complexity and ambiguity make possible a variety of interpretations. Even the identity of its narrator is unclear: are all the disparate voices filtered through any single voice? And, if so, is the voice that of the blind prophet Tiresias, or some other nameless narrator, or is the speaker Eliot himself? This very complexity may in large part be responsible for the continued vitality of the poem, however. Eliot's friend Conrad Aiken maintained that the poem was important primarily for its private "emotional value," and that readers should rely as much on their first responses to the diverse elements of the poem as on the copious and ever-expanding body of scholarship surrounding it. As much as *The Waste Land* has taken its place in history as a central document of the Modernist movement, it retains as well the ability to speak directly to readers.

Rounding out this volume are two of Eliot's most important and influential essays from the period ("Tradition and the Individual Talent" and "The Metaphysical Poets") and a wide selection of contextual materials relating both to Eliot's work and to Modernism as a whole.

A Note on the Text

The indentation of lines is something of an issue with Eliot's poetry. Six years after Eliot's death, the 1971 edition of *The Complete Poems and Plays of T.S. Eliot* introduced without explanation "a new system of indentation of stanzas," indenting the first line of each stanza of "The Love Song of J. Alfred Prufrock," for example, and following a similar practice with a number of other poems. We have not adopted these changes in the formatting of the poems here, preferring instead to rely on the earliest versions of *Prufrock and Other Observations* and *Poems* as copy texts. Although the latter collection was first published with slightly different contents as *Ara Vos Prec* in London, this was a very small printing; we have followed most editors in adopting the selections and organization of *Poems*, the much more widely read American edition.

The early textual history of *The Waste Land* is particularly tangled, with the initial publication in *The Criterion* in October of 1922 followed by its first American publication in November in another periodical, *The Dial*; by the first publication in book form by the New York firm of Boni and Liveright in December of 1922; and then by the Hogarth Press edition in Britain early the next year. The four earliest texts differ in numerous small particulars and in some significant textual respects. Perhaps the most noticeable of these is the indenting of two passages—lines 111-114 and lines 266-291—in the *Criterion* and other early editions, but not in the Boni and Liveright. In that and in most other respects we rely here on the earliest printed version. The Boni and Liveright edition, however, is the earliest edition to include Eliot's notes to the poem. With the convenience of the reader in mind we have included or summarized these here not in the way that they are usually printed, as endnotes following the poem, but rather as footnotes (with Eliot's words clearly differentiated in each case from our own explanatory notes by the inclusion of the phrase "Eliot's note" in square brackets).

Unless otherwise noted, the dates given for each work are that of first publication.

The Love Song of J. Alfred Prufrock[1]

S'io credesse che mia risposta fosse
A persona che mai tornasse al mondo,
Questa fiamma staria senza piu scosse.
Ma perciocche giammai di questo fondo
Non torno viva alcun, s'i'odo il vero,
Senza tema d'infamia ti rispondo.[2]

Let us go then, you and I,
When the evening is spread out against the sky
Like a patient etherized upon a table;
Let us go, through certain half-deserted streets,
The muttering retreats 5
Of restless nights in one-night cheap hotels
And sawdust restaurants with oyster-shells:
Streets that follow like a tedious argument
Of insidious intent
To lead you to an overwhelming question ... 10
Oh, do not ask, "What is it?"
Let us go and make our visit.

In the room the women come and go
Talking of Michelangelo.

The yellow fog that rubs its back upon the window-panes, 15
The yellow smoke that rubs its muzzle on the window-panes
Licked its tongue into the corners of the evening,
Lingered upon the pools that stand in drains,
Let fall upon its back the soot that falls from chimneys,
Slipped by the terrace, made a sudden leap, 20

1 *J. Alfred Prufrock* The name is likely taken from the The Prufrock-Littau Company, a
 furniture dealer located in St. Louis, Eliot's birthplace.
2 *S'io credesse ... ti rispondo* Italian: "If I thought that my reply were given to anyone
 who might return to the world, this flame would stand forever still; but since never
 from this deep place has anyone ever returned alive, if what I hear is true, without
 fear of infamy I answer thee," Dante's *Inferno* 27.61–66; Guido da Montefeltro's
 speech as he burns in Hell.

And seeing that it was a soft October night,
Curled once about the house, and fell asleep.

And indeed there will be time
For the yellow smoke that slides along the street,
25 Rubbing its back upon the window panes;
There will be time, there will be time[1]
To prepare a face to meet the faces that you meet
There will be time to murder and create,
And time for all the works and days[2] of hands
30 That lift and drop a question on your plate;
Time for you and time for me,
And time yet for a hundred indecisions,
And for a hundred visions and revisions,
Before the taking of a toast and tea.

35 In the room the women come and go
Talking of Michelangelo.

And indeed there will be time
To wonder, "Do I dare?" and, "Do I dare?"
Time to turn back and descend the stair,
40 With a bald spot in the middle of my hair—
(They will say: "How his hair is growing thin!")
My morning coat,[3] my collar mounting firmly to the chin,
My necktie rich and modest, but asserted by a simple pin—
(They will say: "But how his arms and legs are thin!")
45 Do I dare
Disturb the universe?
In a minute there is time
For decisions and revisions which a minute will reverse.

For I have known them all already, known them all—
50 Have known the evenings, mornings, afternoons,

1 *there will be time* See Ecclesiastes 3.1–8. "To everything there is a season, and a time
 to every purpose under heaven: A time to be born, and a time to die; a time to plant,
 and a time to pluck up that which is planted; a time to kill, and a time to heal …"
2 *works and days* Title of a poem by eighth-century BCE Greek poet Hesiod.
3 *morning coat* A formal coat with tails.

I have measured out my life with coffee spoons;
I know the voices dying with a dying fall[1]
Beneath the music from a farther room.
 So how should I presume?

And I have known the eyes already, known them all— 55
The eyes that fix you in a formulated phrase,
And when I am formulated, sprawling on a pin,
When I am pinned and wriggling on the wall,
Then how should I begin
To spit out all the butt-ends of my days and ways? 60
 And how should I presume?
And I have known the arms already, known them all—
Arms that are braceleted and white and bare
(But in the lamplight, downed with light brown hair!)
Is it perfume from a dress 65
That makes me so digress?
Arms that lie along a table, or wrap about a shawl.
 And should I then presume?
 And how should I begin?

 * * *

Shall I say, I have gone at dusk through narrow streets 70
And watched the smoke that rises from the pipes
Of lonely men in shirt-sleeves, leaning out of windows? ...[2]
 I should have been a pair of ragged claws
Scuttling across the floors of silent seas.[3]

 * * *

And the afternoon, the evening, sleeps so peacefully! 75
Smoothed by long fingers,

1 *with a dying fall* In Shakespeare's *Twelfth Night* 1.1.1–15. Duke Orsino com-
 mands, "That strain again, it had a dying fall."
2 ... The ellipsis here makes note of a 38-line insertion written by Eliot, entitled
 Prufrock's Pervigilium. The subtitle and 33 of the lines were later removed.
3 *I should ... seas* See Shakespeare's *Hamlet* 2.2, in which Hamlet tells Polonius, "for
 you yourself, sir, should be old as I am, if like a crab you could go backwards."

Asleep ... tired ... or it malingers,
Stretched on the floor, here beside you and me.
Should I, after tea and cakes and ices,
80 Have the strength to force the moment to its crisis?
But though I have wept and fasted, wept and prayed,
Though I have seen my head (grown slightly bald) brought in
 upon a platter,[1]
I am no prophet[2]—and here's no great matter;
I have seen the moment of my greatness flicker,
85 And I have seen the eternal Footman hold my coat, and
 snicker,
And in short, I was afraid.

And would it have been worth it, after all,
After the cups, the marmalade, the tea,
Among the porcelain, among some talk of you and me,
90 Would it have been worth while,
To have bitten off the matter with a smile,
To have squeezed the universe into a ball[3]
To roll it toward some overwhelming question,
To say: "I am Lazarus,[4] come from the dead,
95 Come back to tell you all, I shall tell you all"—
If one, settling a pillow by her head,
 Should say: "That is not what I meant at all;
 That is not it, at all."

And would it have been worth it, after all,
100 Would it have been worth while,
After the sunsets and the dooryards and the sprinkled streets,[5]

1 *brought in upon a platter* Reference to Matthew 14.1–12, in which the prophet John the Baptist is beheaded at the command of Herod, and his head presented to Salomé upon a platter.

2 *I am no prophet* See Amos 7.14. When commanded by King Amiziah not to prophesy, the Judean Amos answered, "I was no prophet, neither was I a prophet's son; but I was a herdsman, and a farmer of sycamore fruit."

3 *squeezed ... ball* See Andrew Marvell's "To His Coy Mistress" 41–2: "Let us roll our strength and all / Our sweetness up into one ball."

4 *Lazarus* Raised from the dead by Jesus in John 11.1–44.

5 *sprinkled streets* Streets sprayed with water to keep dust down.

After the novels, after the teacups, after the skirts that trail
 along the floor—
And this, and so much more?—
It is impossible to say just what I mean!
But as if a magic lantern[1] threw the nerves in patterns on a 105
 screen:
Would it have been worth while
If one, settling a pillow or throwing off a shawl,
And turning toward the window, should say:
 "That is not it at all,
 That is not what I meant, at all." 110

 * * *

No! I am not Prince Hamlet, nor was meant to be;
Am an attendant lord, one that will do
To swell a progress,[2] start a scene or two,
Advise the prince; no doubt, an easy tool,
Deferential, glad to be of use, 115
Politic, cautious, and meticulous;
Full of high sentence,[3] but a bit obtuse;
At times, indeed, almost ridiculous—
Almost, at times, the Fool.

I grow old ... I grow old ... 120
I shall wear the bottoms of my trousers rolled.

Shall I part my hair behind? Do I dare to eat a peach?
I shall wear white flannel trousers, and walk upon the beach.
I have heard the mermaids singing,[4] each to each.

I do not think that they will sing to me. 125

1 *magic lantern* In Victorian times, a device used to project images painted on glass
 onto a blank screen or wall.
2 *progress* Journey made by royalty through the country.
3 *high sentence* Serious, elevated sentiments or opinions.
4 *I have ... singing* See John Donne's "Song": "Teach me to hear the mermaids
 singing."

I have seen them riding seaward on the waves
Combing the white hair of the waves blown back
When the wind blows the water white and black.

We have lingered in the chambers of the sea
130 By sea-girls wreathed with seaweed red and brown
Till human voices wake us, and we drown.

—1915, 1917[1]

1 1915, 1917 The poem was first published in the Chicago magazine *Poetry* in 1915.
Lines 15-34 were added when it appeared in *Prufrock and Other Observations* in 1917.

Portrait of a Lady

Thou hast committed—
Fornication: but that was in another country,
And besides, the wench is dead.[1]

<div align="right">THE JEW OF MALTA</div>

I

Among the smoke and fog of a December afternoon
You have the scene arrange itself—as it will seem to do—
With "I have saved this afternoon for you";
And four wax candles in the darkened room,
Four rings of light upon the ceiling overhead, 5
An atmosphere of Juliet's tomb[2]
Prepared for all the things to be said, or left unsaid.
We have been, let us say, to hear the latest Pole
Transmit the Preludes,[3] through his hair and fingertips.
"So intimate, this Chopin, that I think his soul 10
Should be resurrected only among friends
Some two or three, who will not touch the bloom
That is rubbed and questioned in the concert room."
—And so the conversation slips
Among velleities[4] and carefully caught regrets 15
Through attenuated tones of violins
Mingled with remote cornets
And begins.
"You do not know how much they mean to me, my friends,
And how, how rare and strange it is, to find 20
In a life composed so much, so much of odds and ends,
(For indeed I do not love it ... you knew? you are not blind!
How keen you are!)
To find a friend who has these qualities,

1 *Thou hast ... dead* From Christopher Marlowe, *The Jew of Malta* (c. 1590) 4.1.40-42.

2 *Juliet's tomb* In Shakespeare's *Romeo and Juliet* (c.1591-5), the place where Romeo finds Juliet and, mistakenly thinking she is dead, takes his own life.

3 *the latest Pole ... Preludes* I.e., the most recently famous pianist from Poland playing the short piano pieces, called preludes, of Polish composer Frédéric Chopin (1810-49).

4 *velleities* Idle desires.

25 Who has, and gives
Those qualities upon which friendship lives.
How much it means that I say this to you—
Without these friendships—life, what *cauchemar!*"[1]

Among the windings of the violins
30 And the ariettes[2]
Of cracked cornets
Inside my brain a dull tom-tom begins
Absurdly hammering a prelude of its own,
Capricious monotone
35 That is at least one definite "false note."
—Let us take the air, in a tobacco trance,
Admire the monuments,
Discuss the late events,
Correct our watches by the public clocks.
40 Then sit for half an hour and drink our bocks.[3]

2

Now that lilacs are in bloom
She has a bowl of lilacs in her room
And twists one in her fingers while she talks.
"Ah, my friend, you do not know, you do not know
45 What life is, you who hold it in your hands";
(Slowly twisting the lilac stalks)
"You let it flow from you, you let it flow,
And youth is cruel, and has no more remorse
And smiles at situations which it cannot see."
50 I smile, of course,
And go on drinking tea.
"Yet with these April sunsets, that somehow recall
My buried life, and Paris in the Spring,
I feel immeasurably at peace, and find the world
55 To be wonderful and youthful, after all."

1 *cauchemar* French: nightmare.
2 *ariettas* Short arias.
3 *bocks* Glasses of beer.

The voice returns like the insistent out-of-tune
Of a broken violin on an August afternoon:
"I am always sure that you understand
My feelings, always sure that you feel,
Sure that across the gulf you reach your hand. 60

You are invulnerable, you have no Achilles' heel.
You will go on, and when you have prevailed
You can say: at this point many a one has failed.
But what have I, but what have I, my friend,
To give you, what can you receive from me? 65
Only the friendship and the sympathy
Of one about to reach her journey's end.

I shall sit here, serving tea to friends...."

I take my hat: how can I make a cowardly amends
For what she has said to me? 70
You will see me any morning in the park
Reading the comics and the sporting page.
Particularly I remark
An English countess goes upon the stage.
A Greek was murdered at a Polish dance, 75
Another bank defaulter has confessed.
I keep my countenance,
I remain self-possessed
Except when a street-piano, mechanical and tired
Reiterates some worn-out common song 80
With the smell of hyacinths across the garden
Recalling things that other people have desired.
Are these ideas right or wrong?

3

The October night comes down: returning as before
Except for a slight sensation of being ill at ease 85
I mount the stairs and turn the handle of the door
And feel as if I had mounted on my hands and knees.
"And so you are going abroad; and when do you return?
But that's a useless question.

90 You hardly know when you are coming back,
You will find so much to learn."
My smile falls heavily among the bric-a-brac.

"Perhaps you can write to me."
My self-possession flares up for a second;
95 *This* is as I had reckoned.
"I have been wondering frequently of late
(But our beginnings never know our ends!)
Why we have not developed into friends."
I feel like one who smiles, and turning shall remark
100 Suddenly, his expression in a glass.
My self-possession gutters; we are really in the dark.

"For everybody said so, all our friends,
They all were sure our feelings would relate
So closely! I myself can hardly understand.
105 We must leave it now to fate.
You will write, at any rate.
Perhaps it is not too late.
I shall sit here, serving tea to friends."

And I must borrow every changing shape
110 To find expression ... dance, dance
Like a dancing bear,
Cry like a parrot, chatter like an ape.
Let us take the air, in a tobacco trance—

Well! and what if she should die some afternoon,
115 Afternoon grey and smoky, evening yellow and rose;
Should die and leave me sitting pen in hand
With the smoke coming down above the housetops;
Doubtful, for quite a while
Not knowing what to feel or if I understand
120 Or whether wise or foolish, tardy or too soon . . .
Would she not have the advantage, after all?
This music is successful with a "dying fall"
Now that we talk of dying—
And should I have the right to smile?

Preludes[1]

<center>I</center>

The winter evening settles down
With smell of steaks in passageways.
Six o'clock.
The burnt-out ends of smoky days.
And now a gusty shower wraps 5
The grimy scraps
Of withered leaves about your feet
And newspapers from vacant lots;
The showers beat
On broken blinds and chimney-pots, 10
And at the corner of the street
A lonely cab-horse steams and stamps.
And then the lighting of the lamps.

<center>2</center>

The morning comes to consciousness
Of faint stale smells of beer 15
From the sawdust-trampled[2] street
With all its muddy feet that press
To early coffee-stands.
With the other masquerades
That time resumes, 20
One thinks of all the hands
That are raising dingy shades
In a thousand furnished rooms.

<center>3</center>

You tossed a blanket from the bed,
You lay upon your back, and waited; 25
You dozed, and watched the night revealing

1 *Preludes* In Parts 3 and 4 of this poem, many of the images and details of setting
 are taken from Charles-Louis Philippe's novel *Bubu-de-Montparnasse* (1898).
2 *sawdust-trampled* Sawdust was placed on the floors of bars and restaurants to ab-
 sorb dirt.

The thousand sordid images
Of which your soul was constituted;
They flickered against the ceiling.
30 And when all the world came back
And the light crept up between the shutters,
And you heard the sparrows in the gutters,
You had such a vision of the street
As the street hardly understands;
35 Sitting along the bed's edge, where
You curled the papers from your hair,[1]
Or clasped the yellow soles of feet
In the palms of both soiled hands.

4

His soul stretched tight across the skies
40 That fade behind a city block,
Or trampled by insistent feet
At four and five and six o'clock;
And short square fingers stuffing pipes,
And evening newspapers, and eyes
45 Assured of certain certainties,
The conscience of a blackened street
Impatient to assume the world.
I am moved by fancies that are curled
Around these images, and cling:
50 The notion of some infinitely gentle
Infinitely suffering thing.

Wipe your hand across your mouth, and laugh;
The worlds revolve like ancient women
Gathering fuel in vacant lots.

—1915

1 *papers ... hair* I.e., "curl papers," used to curl hair.

Rhapsody on a Windy Night

Twelve o'clock.
Along the reaches of the street
Held in a lunar synthesis,
Whispering lunar incantations
Dissolve the floors of the memory 5
And all its clear relations,
Its divisions and precisions.
Every street-lamp that I pass
Beats like a fatalistic drum,
And through the spaces of the dark 10
Midnight shakes the memory
As a madman shakes a dead geranium.

Half-past one, .
The street-lamp sputtered,
The street-lamp muttered, 15
The street-lamp said, "Regard that woman
Who hesitates toward you in the light of the door
Which opens on her like a grin.
You see the border of her dress
Is torn and stained with sand, 20
And you see the corner of her eye
Twists like a crooked pin."

The memory throws up high and dry
A crowd of twisted things;
A twisted branch upon the beach 25
Eaten smooth, and polished
As if the world gave up
The secret of its skeleton,
Stiff and white.
A broken spring in a factory yard, 30
Rust that clings to the form that the strength has left
Hard and curled and ready to snap.

Half-past two,
The street-lamp said,

35 "Remark the cat which flattens itself in the gutter,
 Slips out its tongue
 And devours a morsel of rancid butter."
 So the hand of the child, automatic,
 Slipped out and pocketed a toy that was running along the
 quay.
40 I could see nothing behind that child's eye.
 I have seen eyes in the street
 Trying to peer through lighted shutters,
 And a crab one afternoon in a pool,
 An old crab with barnacles on his back,
45 Gripped the end of a stick which I held him.

 Half-past three,
 The lamp sputtered,
 The lamp muttered in the dark.
 The lamp hummed:
50 "Regard the moon,
 La lune ne garde aucune rancune,[1]
 She winks a feeble eye,
 She smiles into corners.
 She smooths the hair of the grass.
55 The moon has lost her memory.
 A washed-out smallpox cracks her face,
 Her hand twists a paper rose,
 That smells of dust and old Cologne,
 She is alone
60 With all the old nocturnal smells
 That cross and cross across her brain.
 The reminiscence comes
 Of sunless dry geraniums
 And dust in crevices,
65 Smells of chestnuts in the streets,
 And female smells in shuttered rooms,
 And cigarettes in corridors
 And cocktail smells in bars."

1 *La lune ... rancune* French: the moon holds no grudges.

The lamp said,
"Four o'clock, 70
Here is the number on the door.
Memory!
You have the key,
The little lamp spreads a ring on the stair.
Mount. 75
The bed is open; the tooth-brush hangs on the wall,
Put your shoes at the door,[1] sleep, prepare for life."

The last twist of the knife.

1 *shoes at the door* I.e., outside the hotel room door, to be cleaned overnight.

Morning at the Window

They are rattling breakfast plates in basement kitchens,
And along the trampled edges of the street
I am aware of the damp souls of housemaids
Sprouting despondently at area gates.

5 The brown waves of fog toss up to me
Twisted faces from the bottom of the street,
And tear from a passer-by with muddy skirts
An aimless smile that hovers in the air
And vanishes along the level of the roofs.

The "Boston Evening Transcript"

The readers of the *Boston Evening Transcript*
Sway in the wind like a field of ripe corn.
When evening quickens faintly in the street,
Wakening the appetites of life in some
And to others bringing the *Boston Evening Transcript,* 5
I mount the steps and ring the bell, turning
Wearily, as one would turn to nod good-bye to La
 Rochefoucauld,[1]
If the street were time and he at the end of the street,
And I say, "Cousin Harriet, here is the *Boston Evening Transcript.*"

1 *La Rochefoucauld* French author François de Marsillac, duc de la Rochefoucauld
(1613-80), author of a collection of *maximes,* concise and frequently cynical aphorisms.

Aunt Helen

Miss Helen Slingsby was my maiden aunt,
And lived in a small house near a fashionable square
Cared for by servants to the number of four.
Now when she died there was silence in heaven[1]
5 And silence at her end of the street.
The shutters were drawn and the undertaker wiped his feet—
He was aware that this sort of thing had occurred before.
The dogs were handsomely provided for,
But shortly afterwards the parrot died too.
10 The Dresden clock[2] continued ticking on the mantelpiece,
And the footman sat upon the dining-table
Holding the second housemaid on his knees—
Who had always been so careful while her mistress lived.

1 *silence in heaven* See Revelation 8.1: "And when he had opened the seventh seal, there was silence in heaven about the space of half an hour."
2 *Dresden clock* A clock cased in highly ornate porcelain.

Cousin Nancy

Miss Nancy Ellicott
Strode across the hills and broke them,
Rode across the hills and broke them—
The barren New England hills—
Riding to hounds 5
Over the cow-pasture.

Miss Nancy Ellicott smoked
And danced all the modern dances;
And her aunts were not quite sure how they felt about it,
But they knew that it was modern. 10

Upon the glazen shelves kept watch
Matthew and Waldo,[1] guardians of the faith,
The army of unalterable law.

1 *Matthew and Waldo* Likely references to British writer Matthew Arnold (1822-88)
and American writer Ralph Waldo Emerson (1803-82).

Mr. Apollinax[1]

Ω τῆς καινότητος. Ἡράκλεις, τῆς παραδοξολογίας εὐμήχανος
ἄνθρωπος.[2]

LUCIAN

When Mr. Apollinax visited the United States
His laughter tinkled among the teacups.
I thought of Fragilion,[3] that shy figure among the birch-trees,
And of Priapus[4] in the shrubbery
5 Gaping at the lady in the swing.
In the palace of Mrs. Phlaccus,[5] at Professor Channing-Cheetah's
He laughed like an irresponsible foetus.
His laughter was submarine and profound
Like the old man of the sea's
10 Hidden under coral islands
Where worried bodies of drowned men drift down in the green
 silence,
Dropping from fingers of surf.
I looked for the head of Mr. Apollinax rolling under a chair
Or grinning over a screen
15 With seaweed in its hair.
I heard the beat of centaur's hoofs over the hard turf
As his dry and passionate talk devoured the afternoon.
"He is a charming man"—"But after all what did he mean?"—
"His pointed ears.... He must be unbalanced."—
20 "There was something he said that I might have challenged."
Of dowager Mrs. Phlaccus, and Professor and Mrs. Cheetah
I remember a slice of lemon, and a bitten macaroon.

1 *Mr. Apollinax* A caricature of Bertrand Russell, a philosopher, mathematician, and
 professor at Harvard (where Eliot studied under him).
2 *Ω τῆς ... ἄνθρωπος* Greek: "Such novelty! Heavens, what paradoxes! How inventive
 he is!" From *Zeuxis*, a dialogue by the Assyrian satirist Lucian (c. 125-80 CE). In the
 passage from which this quotation comes, Lucian is mocking those who show off their
 cleverness.
3 *Fragilion* An invented character, as are the others named here, with the exception of
 Priapus.
4 *Priapus* Roman god of fertility, recognizable by his large permanent erection.
5 *Mrs. Phlaccus* "Flaccus" was a name used by the Fulvius family, a particularly distin-
 guished ancient Roman clan. It may mean "big ears," "floppy," or "fatty."

Hysteria

As she laughed I was aware of becoming involved in her
laughter and being part of it, until her teeth were only
accidental stars with a talent for squad-drill. I was drawn in by
short gasps, inhaled at each momentary recovery, lost finally in
the dark caverns of her throat, bruised by the ripple of unseen
muscles. An elderly waiter with trembling hands was hurriedly
spreading a pink and white checked cloth over the rusty green
iron table, saying: "If the lady and gentleman wish to take their
tea in the garden, if the lady and gentleman wish to take their
tea in the garden ..." I decided that if the shaking of her breasts
could be stopped, some of the fragments of the afternoon
might be collected, and I concentrated my attention with
careful subtlety to this end.

Conversation Galante

I observe: "Our sentimental friend the moon!
Or possibly (fantastic, I confess)
It may be Prester John's[1] balloon
Or an old battered lantern hung aloft
5 To light poor travellers to their distress."
 She then: "How you digress!"

And I then: "Someone frames upon the keys
That exquisite nocturne, with which we explain
The night and moonshine; music which we seize
10 To body forth our own vacuity."
 She then: "Does this refer to me?"
 "Oh no, it is I who am inane."

"You, madam, are the eternal humorist,
The eternal enemy of the absolute,
15 Giving our vagrant moods the slightest twist!
With your air indifferent and imperious
At a stroke our mad poetics to confute—"
 And—"Are we then so serious?"

1 *Prester John* Legendary medieval Christian king said to have ruled the far east.

La Figlia che Piange[1]

O quam te memorem virgo ...[2]

Stand on the highest pavement of the stair—
Lean on a garden urn—
Weave, weave the sunlight in your hair—
Clasp your flowers to you with a pained surprise—
Fling them to the ground and turn 5
With a fugitive resentment in your eyes:
But weave, weave the sunlight in your hair.

So I would have had him leave,
So I would have had her stand and grieve,
So he would have left 10
As the soul leaves the body torn and bruised,
As the mind deserts the body it has used.
I should find
Some way incomparably light and deft,
Some way we both should understand, 15
Simple and faithless as a smile and shake of the hand.

She turned away, but with the autumn weather
Compelled my imagination many days,
Many days and many hours:
Her hair over her arms and her arms full of flowers. 20
And I wonder how they should have been together!
I should have lost a gesture and a pose.
Sometimes these cogitations still amaze
The troubled midnight and the noon's repose.

1 *La Figlia che Piange* Italian: Young Girl Weeping.
2 *O ... virgo* Latin: "What should I call you, maiden?" From Virgil's *Aeneid* 1.327.

Gerontion[1]

*Thou hast nor youth nor age
But as it were an after dinner sleep
Dreaming of both.*[2]

Here I am, an old man in a dry month,
Being read to by a boy, waiting for rain.[3]
I was neither at the hot gates[4]
Nor fought in the warm rain
5 Nor knee deep in the salt marsh, heaving a cutlass,
Bitten by flies, fought.
My house is a decayed house,
And the jew squats on the window sill, the owner,
Spawned in some estaminet[5] of Antwerp,
10 Blistered in Brussels, patched and peeled in London.[6]
The goat coughs at night in the field overhead;
Rocks, moss, stonecrop, iron, merds.[7]
The woman keeps the kitchen, makes tea,
Sneezes at evening, poking the peevish gutter.[8]
15 I an old man,
A dull head among windy spaces.

1 *Gerontion* Greek: little old man. Eliot originally planned to print this poem as a prelude to *The Waste Land*, but when Ezra Pound advised against this he published it separately.

2 *Thou hast ... both* From Shakespeare's *Measure for Measure* 3.1.32–34.

3 *Here I ... rain* These two lines are based on a sentence in A.C. Benson's biography *Edward Fitzgerald* (1905), in which the poet is described as sitting "in a dry month, old and blind, being read to by a country boy, longing for rain."

4 *hot gates* Literal translation of the Greek *Thermopylae*, a pass between northern and central Greece and the location of several historical battles, including that between the Greeks and the Persians in 480 BCE.

5 *estaminet* French: café.

6 *the jew ... London* The association of Jews with images of squalor, decay, and disgusting physicality was one of the many ways in which anti-Semitism was expressed in British literary tradition. For more on the controversy over such elements as they appear in Eliot's verse see the "In Context" section below.

7 *stonecrop* Herb with yellow flowers that grows on rocks or old walls; *merds* Feces.

8 *gutter* Sputtering fire.

Signs are taken for wonders. "We would see a sign!"
The word within a word, unable to speak a word,
Swaddled with darkness.[1] In the juvescence° of the year _youth_
Came Christ the tiger 20

In depraved May, dogwood and chestnut, flowering judas,[2]
To be eaten, to be divided, to be drunk
Among whispers; by Mr. Silvero
With caressing hands, at Limoges[3]
Who walked all night in the next room; 25
By Hakagawa, bowing among the Titians;[4]
By Madame de Tornquist, in the dark room
Shifting the candles; Fraulein von Kulp
Who turned in the hall, one hand on the door.
　　Vacant shuttles 30
Weave the wind. I have no ghosts,
An old man in a draughty house
Under a windy knob.[5]

After such knowledge, what forgiveness? Think now
History has many cunning passages, contrived corridors 35
And issues, deceives with whispering ambitions,
Guides us by vanities. Think now
She gives when our attention is distracted
And what she gives, gives with such supple confusions
That the giving famishes the craving. Gives too late 40
What's not believed in, or if still believed,
In memory only, reconsidered passion. Gives too soon

1　*Signs are ... darkness*　Reference to two Biblical passages. The first is Matthew
　　12.39: "An evil and adulterous generation seeketh after a sign; and there shall no
　　sign be given to it, but the sign of the prophet Jonas," and the second is John 1.1:
　　"In the beginning was the Word, and the Word was with God, and the Word was
　　God." Both of these passages were sources for a Christmas sermon given by Anglican
　　preacher Lancelot Andrewes in 1618.
2　*judas*　Purple-flowered tree of southern Europe named after Judas, who was said to
　　have hanged himself from a tree of this type after betraying Jesus.
3　*Limoges*　French town known for its china of the same name.
4　*Titians*　Paintings by Venetian painter Titian (1485–1576).
5　*Vacant shuttles ... knob*　See Job 7.6–7: "My days are swifter than a weaver's shuttle,
　　and are spent without hope. O remember that my life is wind: mine eye shall no
　　more see good"; *knob*　Knoll.

Into weak hands,[1] what's thought can be dispensed with
Till the refusal propagates a fear. Think
45 Neither fear nor courage saves us. Unnatural vices
Are fathered by our heroism. Virtues
Are forced upon us by our impudent crimes.
These tears are shaken from the wrath-bearing tree.

The tiger springs in the new year. Us he devours. Think at last
50 We have not reached conclusion, when I
Stiffen in a rented house. Think at last
I have not made this show purposelessly
And it is not by any concitation° *stirring up*
Of the backward devils.[2]
55 I would meet you upon this honestly.
I that was near your heart was removed therefrom
To lose beauty in terror, terror in inquisition.
I have lost my passion: why should I need to keep it
Since what is kept must be adulterated?
60 I have lost my sight, smell, hearing, taste and touch:
How should I use them for your closer contact?

These with a thousand small deliberations
Protract the profit of their chilled delirium,
Excite the membrane, when the sense has cooled,
65 With pungent sauces, multiply variety
In a wilderness of mirrors. What will the spider do,
Suspend its operations, will the weevil
Delay? De Bailhache, Fresca, Mrs. Cammel, whirled
Beyond the circuit of the shuddering Bear[3]
70 In fractured atoms. Gull against the wind, in the windy straits

1 *too soon ... hands* See Percy Shelley's *Adonais* (1821), in which he describes Keats's
death: "Too soon, and with weak hands."
2 *backward devils* In Dante's *Inferno*, tellers of the future were punished by being
forced to walk backwards.
3 *Bear* Constellation Ursa Major (the Great Bear).

Of Belle Isle, or running on the Horn,[1]
White feathers in the snow, the Gulf[2] claims,
And an old man driven by the Trades[3]
To a sleepy corner.

 Tenants of the house, 75
Thoughts of a dry brain in a dry season.

 —1920

1 *Belle Isle* Channel between Labrador and Newfoundland at the entrance to the
 Gulf of St. Lawrence; *the Horn* Cape Horn, the southernmost tip of South
 America.
2 *Gulf* Gulf stream, a warm ocean current in the North Atlantic.
3 *Trades* Trade winds, which blow, almost constantly, towards the equator.

Burbank with a Baedeker: Bleistein with a Cigar[1]

*Tra-la- la- la- la- la-laire—nil nisi divinum stabile est; caetera fumus[2]—
the gondola stopped, the old palace was there, how charming its grey and
pink[3]—goats and monkeys, with such hair too![4]—so the countess passed
on until she came through the little park, where Niobe presented her with
à cabinet, and so departed.[5]*

Burbank crossed a little bridge
 Descending at a small hotel;
Princess Volupine arrived,
 They were together, and he fell.[6]

5 Defunctive° music under sea *dying*
 Passed seaward with the passing bell
Slowly: the God Hercules
 Had left him, that had loved him well.[7]

The horses, under the axletree
10 Beat up the dawn from Istria[8]
With even feet. Her shuttered barge
 Burned on the water all the day.

1 *Baedeker* Popular line of guidebooks; *Bleistein* Jewish-German name literally meaning "Leadstone."

2 *nil ... fumus* Latin: Nothing but the divine endures; all the rest is smoke.

3 *the gondola ... pink* From Henry James's *Aspern Papers* (1888), Chapter 1. The passage is narrated by an American woman living in Venice who is giving her visiting friend a tour of the city: "The gondola stopped, the old palace was there.... 'How charming! It's grey and pink!' my companion exclaimed."

4 *goats and monkeys* An exclamation made by Othello in Shakespeare's *Othello* 4.1 (set in Venice) when he becomes convinced his wife is having an affair; *with such hair too* From Robert Browning's "A Toccata of Galuppi's," about the eighteenth-century Venetian composer Baldassare Galuppi (1706–85).

5 *so the ... departed* From the stage directions of *Entertainment of Alice, Dowager Countess of Derby* by John Marston (c.1575–1634); *Niobe* Mother in Greek myth who boasted that her children were better than those of Zeus.

6 *They were ... fell* From Alfred Tennyson's "The Sisters" (Eliot has changed the pronoun from "she" to "he").

7 *Defunctive music ... well* See Shakespeare's *Antony and Cleopatra* 4.3, in which Cleopatra's soldiers hear music just before they are defeated by Caesar's army. "'Tis the god Hercules, whom Antony lov'd, / Now leaves him," one soldier says.

8 *horses ... dawn* In classical myth, the sun is a chariot pulled across the sky; *Istria* Peninsula that juts into the northeast Adriatic.

But this or such was Bleistein's way:
 A saggy bending of the knees
And elbows, with the palms turned out, 15
 Chicago Semite Viennese.

A lustreless protrusive eye
 Stares from the protozoic slime
At a perspective of Canaletto.[1]
 The smoky candle end of time 20

Declines. On the Rialto[2] once.
 The rats are underneath the piles.
The jew is underneath the lot.[3]
 Money in furs.[4] The boatman smiles,

Princess Volupine extends 25
 A meagre, blue-nailed, phthisic° hand *consumptive*
To climb the waterstair. Lights, lights,
 She entertains Sir Ferdinand

Klein. Who clipped the lion's wings[5]
 And flea'd his rump and pared his claws? 30
Thought Burbank, meditating on
 Time's ruins, and the seven laws.[6]

—1919

1 *Canaletto* Italian painter Antonio Canale (1697–1768), famous for his paintings of Venice and London.

2 *Rialto* Island in Venice, containing the old mercantile quarter of the medieval city.

3 *The jew ... lot* In post-1962 editions of Eliot's poems "jew" is capitalized. For a discussion of the controversy over Eliot's attitudes towards Jewish people, see pages 146-48.

4 *Money in furs* Venice was a center for fur trade from the Black Sea.

5 *lion's wings* The winged lion was a symbol of the Venetian Republic.

6 *seven laws* Either the seven laws of architecture that John Ruskin outlined in his *Seven Lamps of Architecture* (1849), which describes Venice's Gothic style as the ideal, or the Noachian Laws, the Seven Commandments of the Sons of Noah from the Jewish Talmud.

Sweeney Erect

> And the trees about me,
> Let them be dry and leafless; let the rocks
> Groan with continual surges; and behind me
> Make all a desolation. Look, look, wenches![1]

Paint me a cavernous waste shore
 Cast in the unstilled Cyclades,[2]
Paint me the bold anfractuous[3] rocks
 Faced by the snarled and yelping seas.

5 Display me Aeolus[4] above
 Reviewing the insurgent gales
Which tangle Ariadne's[5] hair
 And swell with haste the perjured sails.

Morning stirs the feet and hands
10 (Nausicaa[6] and Polypheme).[7]
Gesture of orang-outang
 Rises from the sheets in steam.

This withered root of knots of hair
 Slitted below and gashed with eyes,
15 This oval O cropped out with teeth:
 The sickle motion from the thighs

Jackknifes upward at the knees
 Then straightens out from heel to hip

1 *And the ... wenches* From Francis Beaumont and John Fletcher, *The Maid's Tragedy* (1610) 2.2.
2 *Cyclades* Group of islands in the Aegean.
3 *anfractuous* Here, craggy and rugged.
4 *Aeolus* Greek god of the winds.
5 *Ariadne* In classical mythology, King Minos of Crete's daughter, who helped the hero Theseus escape her father's labyrinth.
6 *Nausicaa* In Homer's *Odyssey*, the beautiful daughter of King Alcinous, who helped Odysseus after his shipwreck.
7 *Polypheme* In the *Odyssey*, the leader of the Cyclopes, a race of one-eyed giants. Polypheme captured Odysseus but was tricked into releasing him.

Pushing the framework of the bed
 And clawing at the pillow slip. 20

Sweeney addressed full length to shave
 Broadbottomed, pink from nape to base,
Knows the female temperament
 And wipes the suds around his face.

(The lengthened shadow of a man 25
 Is history, said Emerson[1]
Who had not seen the silhouette
 Of Sweeney straddled in the sun.)

Tests the razor on his leg
 Waiting until the shriek subsides. 30
The epileptic on the bed
 Curves backward, clutching at her sides.

The ladies of the corridor
 Find themselves involved, disgraced,
Call witness to their principles 35
 And deprecate the lack of taste

Observing that hysteria
 Might easily be misunderstood;
Mrs. Turner intimates
 It does the house no sort of good. 40

But Doris, towelled from the bath,
 Enters padding on broad feet,
Bringing sal volatile[2]
 And a glass of brandy neat.

1 *Emerson* In "Self-Reliance" (1841), Ralph Waldo Emerson describes "an institution" as "the lengthened shadow of a man."

2 *sal volatile* An ammonium carbonate solution used as a restorative in fainting fits.

A Cooking Egg[1]

En l'an trentiesme de mon aage
Que toutes mes hontes j'ay beues ...[2]

Pipit sate[3] upright in her chair
 Some distance from where I was sitting;
Views of the Oxford Colleges
 Lay on the table, with the knitting.

5 Daguerreotypes[4] and silhouettes,
 Her grandfather and great great aunts,
Supported on the mantelpiece
 An *Invitation to the Dance.*[5]

<p style="text-align:center">* * *</p>

I shall not want° Honour in Heaven *lack*
10 For I shall meet Sir Philip Sidney[6]
And have talk with Coriolanus[7]
 And other heroes of that kidney.° *nature*

I shall not want Capital in Heaven
 For I shall meet Sir Alfred Mond.[8]
15 We two shall lie together, lapt° *wrapped up*
 In a five per cent. Exchequer Bond.

1 *Cooking Egg* An egg suitable only for use in cooking.
2 *En l'an ... beues* Fifteenth-century French: "In my thirtieth year, / When I have drunk down all my shames...." From François Villon, *Le Grand Testament* (1498).
3 *sate* I.e., sat; an archaism.
4 *Daguerreotypes* Portraits produced by daguerreotype, an early photographic process introduced in 1839. Silhouettes were another form of portraiture common at the time.
5 *An Invitation to the Dance* Probably the sheet music to a nineteenth-century song of that name by Carl Maria von Weber (1786-1826).
6 *Sir Philip Sidney* Prominent English Elizabethan poet (1554-86).
7 *Coriolanus* Proud Roman general depicted in Shakespeare's tragedy of that name.
8 *Sir Alfred Mond* Wealthy British industrialist of Jewish heritage (1868-1930), founder of Imperial Chemical Industries. From the medieval period onward the stereotype of the Jewish financier is recurrent in English literature—and in English attitudes. For a discussion of the controversy over Eliot's use of such harmful stereotypes, see the "In Context" section on "Eliot and Anti-Semitism" later in this volume.

I shall not want Society in Heaven,
 Lucretia Borgia[1] shall be my Bride;
Her anecdotes will be more amusing
 Than Pipit's experience could provide. 20

I shall not want Pipit in Heaven:
 Madame Blavatsky[2] will instruct me
In the Seven Sacred Trances;[3]
 Piccarda de Donati[4] will conduct me.

<p style="text-align:center">* * *</p>

But where is the penny world[5] I bought 25
 To eat with Pipit behind the screen?
The red-eyed scavengers are creeping
 From Kentish Town and Golder's Green;[6]

Where are the eagles[7] and the trumpets?

 Buried beneath some snow-deep Alps. 30
Over buttered scones and crumpets
 Weeping, weeping multitudes
Droop in a hundred A.B.C.'s.[8]

1 *Lucretia Borgia* Duchess of Ferrara (1480-1519), whose family was known for engaging in ruthless political intrigue and poisoning its enemies.

2 *Madame Blavatsky* Helena Petrovna Lavatsky (1831-91), spiritualist and founder of the Theosophical Society.

3 *Seven Sacred Trances* Secret doctrines of the Theosophical Society.

4 *Piccarda de Donati* The nun who instructs Dante in heaven; see canto 3 of his *Paradiso*.

5 *penny world* Round candy or cake that could be bought for a penny.

6 *Kentish Town and Golder's Green* North London suburbs.

7 *eagles* Symbol of the Roman Empire.

8 [Eliot's note] *I.e.,* an endemic teashop, found in all parts of London. The initials signify: Aerated Bread Company, Limited.

Le Directeur

Malheur à la malheureuse Tamise!
Qui coule si près du Spectateur.
Le directeur
Conservateur
5 Du Spectateur
Empeste la brise.
Les actionnaires
Reactionnaires
Du Spectateur
10 Conservateur
Bras dessus bras dessous
Font des tours
A pas de loup.
Dans un égout
15 Une petite fille
En guenilles
Camarde
Regarde
Le directeur
20 Du Spectateur
Conservateur
Et crève d'amour.[1]

1 *Le Directuer ... d'amour* French: *The Director*. Woe unto the miserable Thames, which runs so close to *The Spectator*. The conservative director of *The Spectator* infects the breeze [i.e., stinks]. The reactionary stockholders of the conservative *Spectator* parade stealthily arm in arm. In a gutter, a snub-nosed little girl in rags looks at the director of the conservative *Spectator* and dies of love. [*Spectator* High-brow weekly London magazine.]

Mélange Adultère de Tout

En Amérique, professeur;
En Angleterre, journaliste;
C'est à grands pas et en sueur
Que vous suivrez à peine ma piste.
En Yorkshire, conférencier; 5
A Londres, un peu banquier,
Vous me paierez bien la tête.
C'est à Paris que je me coiffe
Casque noir de jemenfoutiste.
En Allemagne, philosophe 10
Surexcité par Emporheben
Au grand air de Bergsteigleben;
J'erre toujours de-ci de-là
A divers coups de tra là là
De Damas jusqu'à Omaha; 15
Je célébrai mon jour de fête
Dans une oasis d'Afrique
Vêtu d'une peau de girafe.

On montrera mon cénotaphe
Aux côtes brûlantes de Mozambique.[1] 20

1 *Mélange ... Mozambique* French: *Adulterous Mixture of Everything.* In America, a
teacher; in England, a journalist; with big steps and in a sweat you will barely follow
my tracks. In Yorkshire, a lecturer; in London, a bit of a banker; you will pay me well
by the head. In Paris I wear a black hat of couldn't-care-less. In Germany, a philosopher
over-excited by elevation, in the open air of love of mountaineering; I always wander
from here to there, with some tra-la-la from Damascus to Omaha. I will celebrate my
feast day in an African oasis, clad in a giraffe's skin. They will display my cenotaph on
the burning coast of Mozambique. [*cenotaph* Sepulchral monument for one whose
body is elsewhere.]

Lune de Miel

Ils ont vu les Pay-Bas, ils rentrent à Terre Haute;
Mais une nuit d'été, les voici à Ravenne,
A l'aise entre deux draps, chez deux centaines de punaises;
La sueur aestivale, et une forte odeur de chienne.
5 Ils restent sur le dos écartant les genoux
De quatre jambes molles tout gonflées de morsures.
On relève le drap pour mieux égratigner.
Moins d'une lieue d'ici est Saint Apollinaire
En Classe, basilique connue des amateurs
10 De chapitaux d'acanthe que tournoie le vent.

Ils vont prendre le train de huit heures
Prolonger leurs misères de Padoue à Milan
Où se trouve la Cène, et un restaurant pas cher.
Lui pense aux pourboires, et rédige son bilan.
15 Ils auront vu la Suisse et traversé la France.
Et Saint Apollinaire, raide et ascétique,
Vieille usine desaffectée de Dieu, tient encore
Dans ses pierres écroulantes la forme précise de Byzance.[1]

1 *Lune de ... Byzance* French: *Honeymoon.* They saw the Netherlands [The Low Coun-
tries], they returned to Terre Haute [High Land]; but one summer night, here they
are in Ravenna, at ease between two sheets, with two hundred bedbugs. The summer
sweat, and a strong smell of bitch. They remain on their backs spreading the knees
of four legs all swollen from bites. One lifts up the sheet the better to scratch. Less
than a league from here is Saint Apollinaire in Classe, a basilica known by lovers of
acanthus column-tops around which the wind swirls. They will take the 8 o'clock
train to prolong their misery from Padua to Milan where one finds the Last Supper,
and a cheap restaurant. He thinks about tips and edits his balance sheet. They will
have seen Switzerland and traversed France. And St. Apollinaire, stiff and ascetic, old
disused factory of God, still holds in its crumbling stones the precise form of Byzan-
tium. [*league* Measurement of distance equal to roughly three miles.]

The Hippopotamus

*Similiter et omnes revereantur Diaconos, ut mandatum Jesu
Christi; et Episcopum, ut Jesum Christum, existentem filium Patris;
Presbyteros autem, ut concilium Dei et conjunctionem Apostolorum.
Sine his Ecclesia non vocatur; de quibus suadeo vos sic habeo.*[1]

<div align="right">S. Ignatii Ad Trallianos</div>

*And when this epistle is read among you, cause that
it be read also in the church of the Laodiceans.*[2]

The broad-backed hippopotamus
Rests on his belly in the mud;
Although he seems so firm to us
He is merely flesh and blood.

Flesh and blood is weak and frail, 5
Susceptible to nervous shock;
While the True Church can never fail
For it is based upon a rock.[3]

The hippo's feeble steps may err
In compassing material ends, 10
While the True Church need never stir
To gather in its dividends.

The 'potamus can never reach
The mango on the mango-tree;
But fruits of pomegranate and peach 15
Refresh the Church from over sea.

1 *Similiter ... habeo* Latin: "In the same manner all should revere the deacons, and the
 Bishops, as Jesus Christ, the living son of the Father, commanded; and also the Priests,
 as the council of God and union of the Apostles. Without these the Church may not
 be so called, and what I urge upon you is what I myself believe." From the Letter to
 the Trallians, written by Saint Ignatius of Antioch (first century CE), an early Christian
 theologian.

2 *And when ... Laodiceans* From Colossians 4.16. In Revelation 3.15-18, the La-
 odiceans are criticized for spiritual lukewarmness and overconfidence.

3 *based upon a rock* See Matthew 16.18: "Thou art Peter, and upon this rock I will
 build my church."

At mating time the hippo's voice
Betrays inflexions hoarse and odd,
But every week we hear rejoice
20 The Church, at being one with God.

The hippopotamus's day
Is passed in sleep; at night he hunts;
God works in a mysterious way—
The Church can sleep and feed at once.

25 I saw the 'potamus take wing
Ascending from the damp savannas,
And quiring° angels round him sing *choiring*
The praise of God, in loud hosannas.

Blood of the Lamb[1] shall wash him clean
30 And him shall heavenly arms enfold,
Among the saints he shall be seen
Performing on a harp of gold.

He shall be washed as white as snow,
By all the martyr'd virgins lost,
35 While the True Church remains below
Wrapt in the old miasmal° mist. *putrid*

1 *Blood of the Lamb* See Revelation 7.14.

Dans le Restaurant

Le garcon délabré qui n'a rien à faire
Que de se gratter les doigts et se pencher sur mon épaule:
 "Dans mon pays il fera temps pluvieux,
 Du vent, du grand soleil, et de la pluie;
 C'est ce qu'on appelle le jour de lessive des gueux." 5
(Bavard, baveux, à la croupe arrondie,
Je te prie, au moins, ne bave pas dans la soupe).
 "Les saules trempés, et des bourgeons sur les ronces—
 C'est là, dans une averse, qu'on s'abrite.
J'avais sept ans, elle était plus petite. 10
 Elle était toute mouillée, je lui ai donné des primevères."
Les taches de son gilet montent au chiffre de trente-huit.
 "Je la chatouillais, pour la fair rire.
 Elle avait une odeur fraiche, qui m'était inconnue."

Mais alors, vieux lubrique, à cet âge ... 15
"Monsieur, le fait est dur.
 Il est venu, nous peloter, un gros chien;
 Moi j'avais peur, je l'ai quittée à mi-chemin.
 C'est dommage."
 Mais alors, tu as ton vautour! 20
Va t'en te décrotter les rides du visage;
Tiens, ma fourchette, décrasse-toi le crâne.
De quel droit payes-tu des expériences comme moi?
Tiens, voilà dix sous, pour la salle-de-bains.[1]

1 *Dans le ... salle-de-bains* French: *In the Restaurant.* The run down waiter who has
nothing to do but scratch his fingers and lean on my shoulder: "In my country, it will
be the rainy season, some wind, some strong sun, and some rain. It's what we call the
beggar's laundry day." (Chatterbox, drooling, with a round rump, I beg you at least not
to dribble in the soup.) "The wet willows and the buds on the blackberry bushes. It is
here, in a downpour, that one finds shelter. I was seven years old, she was smaller. She
was completely soaked, I gave her primroses." The stains on his waistcoat added up to
thirty-eight. "I tickled her, to make her laugh. She had a fresh smell that was unknown
to me."
 But, lewd old man, at that age ... "Sir, the fact is hard. He came, to paw us, a
large dog. Me, I was afraid, and I left midway. It's a shame." But then, you have your
vulture! Go away and scrub the wrinkles on your face. Here, my fork, scrub your skull.
By what right do you pay for experiences like me? Hold on, here are ten cents, for the
bathroom.

25 Phlébas, le Phénicien, pendant quinze jours noyé,
 Oubliait les cris des mouettes et la houle de Cornouaille,
 Et les profits et les pertes, et la caigaison d'étain:
 Un courant de sous-mer l'emporta très loin,
 Le repassant aux étapes de sa vie antérieure.
30 Figurez-vous donc, c'était un sort pénible;
 Cependant, ce fut jadis un bel homme, de haute taille.[1]

1 *Phlébas ... taille* French: Phlebus, the Phoenician, dead for fifteen days, forgot the
 cries of gulls and the swell of Cornwall, and the profits and the losses, and the cargo
 ships of pewter: An undertow carried him very far, passing the stages of his former life.
 Go figure then, it was a hard lot. Nevertheless, he was once a handsome man, of great
 stature.

Whispers of Immortality

Webster[1] was much possessed by death
And saw the skull beneath the skin;
And breastless creatures under ground
Leaned backward with a lipless grin.

Daffodil bulbs instead of balls 5
Stared from the sockets of the eyes!
He knew that thought clings round dead limbs
Tightening its lusts and luxuries.

Donne,[2] I suppose, was such another
Who found no substitute for sense, 10
To seize and clutch and penetrate;
Expert beyond experience,

He knew the anguish of the marrow
The ague° of the skeleton; *shivering fit*
No contact possible to flesh 15
Allayed the fever of the bone.

 * * *

Grishkin[3] is nice: her Russian eye
Is underlined for emphasis;
Uncorseted, her friendly bust
Gives promise of pneumatic[4] bliss. 20

The couched Brazilian jaguar
Compels the scampering marmoset
With subtle effluence of cat;
Grishkin has a maisonnette;[5]

1 *Webster* English Jacobean dramatist John Webster (c.1581-c.1625).
2 *Donne* English metaphysical poet John Donne (1572-1631).
3 *Grishkin* Character based on Russian ballet dancer Serafima Astafieva (1876-1934),
 whom Eliot met through Ezra Pound.
4 *pneumatic* I.e., filled with compressed air; can also mean "spiritual."
5 *maisonette* Small house or apartment.

25 The sleek Brazilian jaguar
 Does not in its arboreal gloom
 Distil so rank a feline smell
 As Grishkin in a drawing-room.

 And even the Abstract Entities
30 Circumambulate[1] her charm;
 But our lot crawls between dry ribs
 To keep our metaphysics warm.

1 *Circumambulate* Walk around.

Mr. Eliot's Sunday Morning Service

Look, look, master, here comes two religious caterpillars.[1]

<div align="right">THE JEW OF MALTA</div>

Polyphiloprogenitive[2]
The sapient sutlers[3] of the Lord
Drift across the window-panes.
In the beginning was the Word.[4]

In the beginning was the Word. 5
Superfetation[5] of τὸ ἕν,[6]
And at the mensual° turn of time *monthly*
Produced enervate° Origen.[7] *emasculated; weakened*

A painter of the Umbrian school[8]
Designed upon a gesso ground[9] 10
The nimbus° of the Baptized God. *halo*
The wilderness is cracked and browned.

But through the water pale and thin
Still shine the unoffending feet
And there above the painter set 15
The Father and the Paraclete.° *Holy Spirit*

<div align="center">* * *</div>

1 *Look ... caterpillars* From Christopher Marlowe, *The Jew of Malta* (first performed
 1592) 4.1.21.
2 *Polyphiloprogenitive* Word created by Eliot, meaning extremely fertile or fecund.
3 *sutlers* Those who sell provisions to soldiers.
4 *In the ... Word* See John 1.1.
5 *Superfetation* Multiple impregnation.
6 *τὸ ἕν* Greek: the one.
7 *Origen* Origen of Alexandria (c. 185-254 CE), Christian theologian and biblical
 scholar.
8 *Umbrian school* Fifteenth-century school of painters associated with the town of Um-
 bria in North Italy.
9 *gesso ground* Plaster surface used as a foundation for painting.

The sable presbyters° approach *priests*
The avenue of penitence;
The young are red and pustular° *pimply*
20 Clutching piaculative pence.[1]

Under the penitential gates
Sustained by staring Seraphim° *angels*
Where the souls of the devout
Burn invisible and dim.

25 Along the garden-wall the bees
With hairy bellies pass between
The staminate and pistillate,[2]
Blest office of the epicene.[3]

Sweeney shifts from ham to ham
30 Stirring the water in his bath.
The masters of the subtle schools
Are controversial, polymath.[4]

1 *piaculative pence* Pence (pennies) given in the hopes of making amends for sins.
2 *staminate and pistillate* I.e., male and female [flowers].
3 *epicene* I.e., one with characteristics of neither or both sexes.
4 *polymath* I.e., involving great and varied knowledge.

Sweeney Among the Nightingales

ὤμοι, πέπληγμαι καιρίαν πληγὴν ἔσω.[1]

Apeneck Sweeney spreads his knees
Letting his arms hang down to laugh,
The zebra stripes along his jaw
Swelling to maculate[2] giraffe.

The circles of the stormy moon
Slide westward toward the River Plate,[3]
Death and the Raven drift above
And Sweeney guards the hornèd gate.[4]

Gloomy Orion and the Dog[5]
Are veiled; and hushed the shrunken seas;
The person in the Spanish cape
Tries to sit on Sweeney's knees

Slips and pulls the table cloth
Overturns a coffee-cup,
Reorganized upon the floor
She yawns and draws a stocking up;

The silent man in mocha brown
Sprawls at the window-sill and gapes;
The waiter brings in oranges
Bananas figs and hothouse grapes;

1 ὤμοι ... ἔσω Greek: "Alas, I have been struck deep with a deadly wound." From Aeschylus (525-456 BCE), *Agamemnon*. This line is spoken from offstage by King Agamemnon when he is slain by his wife Clytemnestra.

2 *maculate* Spotted; also soiled, tainted.

3 *River Plate* I.e., the Río de la Plata, an inlet of the Atlantic Ocean located between Argentina and Uruguay.

4 *hornèd gate* In Homer's *Odyssey*, the gate through which true dreams pass.

5 *Gloomy Orion and the Dog* The constellation Orion and Sirius (sometimes referred to as "the Dog Star"), one of the stars within Orion. The phrase "Gloomy Orion" here and the phrase "murderous paws" on line 24 are both taken from Christopher Marlowe's *Dido, Queen of Carthage* (1594). See 1.2.26 and 2.1.512, respectively.

The silent vertebrate exhales,
Contracts and concentrates, withdraws;
Rachel *née* Rabinovitch
Tears at the grapes with murderous paws;

25 She and the lady in the cape
Are suspect, thought to be in league;
Therefore the man with heavy eyes
Declines the gambit, shows fatigue,

Leaves the room and reappears
30 Outside the window, leaning in,
Branches of wistaria
Circumscribe a golden grin;

The host with someone indistinct
Converses at the door apart,
35 The nightingales are singing near
The Convent of the Sacred Heart,

And sang within the bloody wood
When Agamemnon cried aloud
And let their liquid siftings fall
40 To stain the stiff dishonoured shroud.

The Waste Land[1]

"Nam Sibyllam quidem Cumis ego ipse oculis meis vidi in ampulla pendere, et cum illi pueri dicerent: Σίβυλλα τί θέλεις; respondebat illa: ἀποθανεῖν θέλω."[2]

For Ezra Pound

il miglior fabbro.[3]

I. THE BURIAL OF THE DEAD[4]

April is the cruellest month, breeding
Lilacs out of the dead land, mixing
Memory and desire, stirring
Dull roots with spring rain.
Winter kept us warm, covering
Earth in forgetful snow, feeding
A little life with dried tubers. 5
Summer surprised us, coming over the Starnbergersee[5]
With a shower of rain; we stopped in the colonnade,

1 [Eliot's note] Not only the title, but the plan and a good deal of the incidental symbolism of the poem were suggested by Miss Jessie L. Weston's book on the Grail legend: *From Ritual to Romance* (Cambridge). Indeed, so deeply am I indebted, Miss Weston's book will elucidate the difficulties of the poem much better than my notes can do; and I recommend it (apart from the great interest of the book itself) to any who think such elucidation of the poem worth the trouble. To another work of anthropology I am indebted in general, one which has influenced our generation profoundly; I mean [Sir James Frazer's 1890 to 1915 twelve-volume] *The Golden Bough*; I have used especially the two volumes *Adonis, Attis, Osiris*. Anyone who is acquainted with these works will immediately recognise in the poem certain references to vegetation ceremonies.

2 *Nam ... θέλω* Latin and Greek: "For once I saw with my own eyes the Sybil at Cumae hanging in a cage, and when the boys asked her, 'Sybil, what do you want?' she responded, 'I want to die.'" From the *Satyricon* of Petronius Arbiter (first-century CE Roman writer). The most famous of the prophetic Sibyls of Greek mythology, the Cumaean Sibyl received immortality from the god Apollo, but neglected to ask him for eternal youth.

3 *il miglior fabbro* Italian: the better craftsman. This compliment was originally paid by Dante, in his *Purgatorio* (26.117), to the Provençal poet Arnaut Daniel. Eliot adopts it for his dedication to fellow expatriate and Modernist American poet, Ezra Pound (1885–1972), who played a key editorial role in the poem's production.

4 *The Burial of the Dead* Reference to the Anglican Order for the Burial of the Dead.

5 *Starnbergersee* Lake near Munich, Germany.

10 And went on in sunlight, into the Hofgarten,[1]
And drank coffee, and talked for an hour.
Bin gar keine Russin, stamm' aus Litauen, echt deutsch.[2]
And when we were children, staying at the archduke's,
My cousin's, he took me out on a sled,
15 And I was frightened. He said, Marie,
Marie, hold on tight. And down we went.
In the mountains, there you feel free.
I read, much of the night, and go south in the winter.

What are the roots that clutch, what branches grow
20 Out of this stony rubbish? Son of man,[3]
You cannot say, or guess, for you know only
A heap of broken images, where the sun beats,
And the dead tree gives no shelter, the cricket no relief,[4]
And the dry stone no sound of water. Only
25 There is shadow under this red rock,[5]
(Come in under the shadow of this red rock),
And I will show you something different from either
Your shadow at morning striding behind you
Or your shadow at evening rising to meet you;
30 I will show you fear in a handful of dust.
 Frisch weht der Wind
 Der Heimat zu

1 *Hofgarten* Public park in Munich.
2 *Bin ... deutsch* German: I'm not Russian at all, I come from Lithuania, a true German.
3 *Son of man* Eliot's note cites Ezekiel 2.1, in which God addresses Ezekiel, whose mission will be to preach the coming of the Messiah to unbelievers, saying, "Son of man, stand upon thy feet, and I will speak unto thee."
4 *cricket no relief* Eliot's note cites Ecclesiastes 12.5, in which the preacher speaks of the fearful deprivations of old age: "Also *when* they shall be afraid of *that which is* high, and fears *shall be* in the way, and the almond tree shall flourish, and the grasshopper shall be a burden, and desire shall fail: because man goeth to his long home, and the mourners go about the streets...."
5 *There is shadow ... rock* See Isaiah 32.2, which describes a kingdom under righteous rule: "And a man shall be as an hiding place from the wind, and a covert from the tempest; as rivers of water in a dry place, as the shadow of a great rock in a weary land."

Mein Irisch Kind,
　　Wo weilest du?[1]
"You gave me hyacinths first a year ago;　　　　　　　　35
They called me the hyacinth girl."
—Yet when we came back, late, from the Hyacinth garden,
Your arms full, and your hair wet, I could not
Speak, and my eyes failed, I was neither
Living nor dead, and I knew nothing,
Looking into the heart of light, the silence.
Oed' und leer das Meer.[2]

Madame Sosostris,[3] famous clairvoyante,
Had a bad cold, nevertheless
Is known to be the wisest woman in Europe,　　　　　　　45
With a wicked pack of cards.[4] Here, said she,
Is your card, the drowned Phoenician Sailor,
(Those are pearls that were his eyes.[5] Look!)

1　*Frisch … du*　German: "Fresh blows the wind to the homeland—my Irish child, where do you tarry?" From Richard Wagner's opera *Tristan und Isolde* (1865), 1.5–8, this is a sailor's lament for the girl he has left behind in Ireland.

2　*Oed' … Meer*　German: "Desolate and empty is the sea." Eliot's note cites *Tristan und Isolde* 3.24, in which Tristan lies dying, waiting for his beloved, Isolde, to come to him, but there is no sign of her ship on the sea.

3　*Madame Sosostris*　This name is often thought to have been "unconsciously" borrowed by Eliot from the name of the fortune-teller Madame Sesostris in Aldous Huxley's novel *Crome Yellow* (1921). It may more plausibly have derived from the Greek word for savior, *soteros.*

4　[Eliot's note]　I am not familiar with the exact constitution of the Tarot pack of cards, from which I have obviously departed to suit my own convenience. The Hanged Man, a member of the traditional pack, fits my purpose in two ways: because he is associated in my mind with the Hanged God of Frazer, and because I associate him with the hooded figure in the passage of the disciples to Emmaus in Part V. The Phoenician Sailor and the Merchant appear later; also the "crowds of people," and Death by Water is executed in Part IV. The Man with Three Staves (an authentic member of the Tarot pack) I associate, quite arbitrarily, with the Fisher King himself. [The Tarot pack, generally used for fortune-telling, consists of 78 cards, 22 of which are trump cards (or "major arcana"). The remaining 56 belong to one of the four suits—cups, wands, swords, and pentangles. The Tarot originated in France and Italy in the fourteenth century.]

5　*Those are … eyes*　From Ariel's song in Shakespeare's *The Tempest* 1.2.397-403: "Full fathom five thy father lies; / Of his bones are coral made; / Those are pearls that were his eyes; / Nothing of him that doth fade / But doth suffer a sea-change / Into something rich and strange; / Sea nymphs hourly ring his knell: / *Burden.* Ding-dong. / Hark! Now I hear them—ding-dong bell."

Here is Belladonna, the Lady of the Rocks,[1]
50 The lady of situations. → *a job (not for women), predicaments*
Here is the man with three staves, and here the Wheel,[2]
And here is the one-eyed merchant, and this card,
reference to the Fisher King Jesus
Which is blank, is something he carries on his back,
Which I am forbidden to see. I do not find → *she cannot find him like how Percival couldn't*
55 The Hanged Man. Fear death by water.
I see crowds of people, walking round in a ring.
Thank you. If you see dear Mrs. Equitone,
Tell her I bring the horoscope myself:
ask for the cup, and we don't ask for available knowledge
One must be so careful these days.

60 Unreal City,[4]
Under the brown fog of a winter dawn,
A crowd flowed over London Bridge, so many,
I had not thought death had undone so many.[5]
Sighs, short and infrequent, were exhaled,
→ *like a busy businessman looking at his feet walking*
65 And each man fixed his eyes before his feet.
Flowed up the hill and down King William Street,
To where Saint Mary Woolnoth[6] kept the hours
With a dead sound on the final stroke of nine.[7]

1 *Belladonna* Italian: beautiful woman. Also another name for the poisonous plant deadly nightshade, once used for cosmetic purposes by Italian women; *Lady of the Rocks* Possible ironic reference to Leonardo da Vinci's painting *Madonna of the Rocks*.
2 *Wheel* Wheel of Fortune.
3 *Hanged Man* This Tarot card shows a man hanging by one foot from a T-shaped cross. It can have a range of meanings related to suspension, withdrawal, and waiting. As Eliot's note to the pack of cards indicates, he follows Jessie Weston, in *From Ritual to Romance*, in linking this Hanged Man with the "Hanged God" of James Frazer's *The Golden Bough*. This man's self-sacrifice in the role of fertility god is necessary for the annual rejuvenation of the land.
4 *Unreal City* Eliot's note cites the following lines from the 1859 poem "Les sept vieillards" by poet Charles Baudelaire: "Fourmillante cité, cité pleine de rêves, / Où le spectre en plein jour raccroche le passant!" (French: "Swarming city, city full of dreams, / Where the daylight specter intercepts the passerby!") "The City" is the name for London's financial district, located north of London Bridge.
5 *so many ... so many* Eliot's note cites Dante's *Inferno* 3.55–57, which describes the souls in Hell's vestibule: "such a long stream / of people, that I would not have thought / that death had undone so many." These vestibule inhabitants "undecided stood" (3.39) in passive moral stagnancy, refusing to choose good or bad.
6 *Saint Mary Woolnoth* Church in King William Street. Eliot joined a campaign to have this church, and others like it that were slated for demolition, preserved.
7 [Eliot's note] A phenomenon which I have often noticed. → *"I've read this before"*

66 T.S. ELIOT

There I saw one I knew, and stopped him, crying "Stetson![1]
You who were with me in the ships at Mylae![2] 70
That corpse you planted last year in your garden,
Has it begun to sprout? Will it bloom this year?
Or has the sudden frost disturbed its bed?
Oh keep the Dog far hence, that's friend to men,
Or with his nails he'll dig it up again![3] 75
You! hypocrite lecteur!—mon semblable,—mon frère!"[4]

2. A Game Of Chess[5]

The Chair she sat in, like a burnished throne,[6]
Glowed on the marble, where the glass
Sustained by standards wrought with fruited vines
From which a golden Cupidon peeped out 80
(Another hid his eyes behind his wing)
Doubled the flames of sevenbranched candelabra
Reflecting light upon the table as
The glitter of her jewels rose to meet it,
From satin cases poured in rich profusion; 85
In vials of ivory and coloured glass
Unstoppered, lurked her strange synthetic perfumes,
Unguent, powdered, or liquid—troubled, confused

1 *Stetson* Eliot, when questioned, maintained this was a reference to the average City
 clerk, and not, as some had suggested, to Ezra Pound, whose nickname was "Buffalo
 Bill."

2 *Mylae* The Battle of Mylae (260 BCE) took place during the trade-based First Punic
 War between the Romans and the Carthaginians.

3 *O keep ... again* Eliot's note cites the dirge in John Webster's play *The White Devil*
 (1612) 5.4: "But keep the wolf far thence, that's foe to men, / For with his nails he'll
 dig them up again." Sirius, the Dog Star, heralded the annual flooding of the Nile in
 Egyptian mythology.

4 *hypocrite ... mon frère* French: "Hypocrite reader—my double—my brother!"
 Eliot's note cites the preface of Baudelaire's *Fleurs du Mal*.

5 *A Game of Chess* Title of Thomas Middleton's 1624 satirical political drama. In
 Middleton's play *Women Beware Women*, a game of chess distracts a mother-in-law,
 preventing her from noticing that her daughter-in-law is being seduced upstairs.
 Each move in the chess game mirrors a move in the seduction.

6 [Eliot's note] Cf. Antony and Cleopatra, 2.2.190. [This is the beginning of
 Enorbarbus's description of the first meeting of Antony and Cleopatra: "The barge
 she sat in, like a burnished throne, / Burned on the water."]

And drowned the sense in odours; stirred by the air
90 That freshened from the window, these ascended
In fattening the prolonged candle-flames,
Flung their smoke into the laquearia,[1]
Stirring the pattern on the coffered ceiling.
Huge sea-wood fed with copper
95 Burned green and orange, framed by the coloured stone,
In which sad light a carved dolphin swam.
Above the antique mantel was displayed
As though a window gave upon the sylvan scene[2]
The change of Philomel, by the barbarous king
100 So rudely forced;[3] yet there the nightingale
Filled all the desert with inviolable voice
And still she cried, and still the world pursues,
"Jug Jug"[4] to dirty ears.
And other withered stumps of time
105 Were told upon the walls; staring forms
Leaned out, leaning, hushing the room enclosed.
Footsteps shuffled on the stair.
Under the firelight, under the brush, her hair
Spread out in fiery points
110 Glowed into words, then would be savagely still.

"My nerves are bad to-night. Yes, bad. Stay with me.
Speak to me. Why do you never speak? Speak.
 What are you thinking of? What thinking? What?
I never know what you are thinking. Think."

1 *laquearia* Latin: paneled ceiling. Eliot's note cites Virgil's *Aeneid* 1.726, describing a banquet given by Queen Dido of Carthage for her soon-to-be lover, Aeneas: "Burning lamps hang from the gold-paneled ceiling, and torches dispel the night with their flames."

2 *sylvan scene* Eliot's note cites Milton's *Paradise Lost* 4.140, which describes the Garden of Eden seen through Satan's eyes.

3 *The change … forced* Eliot's notes for this passage cite Greek poet Ovid's *Metamorphoses* 6, which tells the Greek myth of Philomela, who was raped and had her tongue cut out by King Tereus of Thrace (her sister's husband) before being changed into a nightingale.

4 *Jug Jug* In Elizabethan poetry, a conventional representation of a nightingale's song. Also, a crude reference to sexual intercourse.

I think we are in rats' alley[1] 115
Where the dead men lost their bones.

 "What is that noise?"
 The wind under the door.[2]
"What is that noise now? What is the wind doing?"
 Nothing again nothing. 120
 "Do
You know nothing? Do you see nothing? Do you remember
Nothing?"

I remember
Those are pearls that were his eyes. 125
"Are you alive, or not? Is there nothing in your head?"
 But
O O O O that Shakespeherian Rag[3]—
It's so elegant
So intelligent 130
"What shall I do now? What shall I do?
I shall rush out as I am, and walk the street
With my hair down, so. What shall we do to-morrow?
What shall we ever do?"
 The hot water at ten. 135
And if it rains, a closed car at four.
And we shall play a game of chess,
Pressing lidless eyes and waiting for a knock upon the door.[4]

When Lil's husband got demobbed,[5] I said—
I didn't mince my words, I said to her myself, 140
HURRY UP PLEASE ITS TIME[6]

1 [Eliot's note] Cf. part 3, line 195 [of *Metamorphoses* 6].
2 *The wind … door* Eliot's note cites a line from John Webster's *The Devil's Law Case*
 (3.2.162). A patient who is believed to have been stabbed to death groans in pain,
 prompting the surgeon to ask, "Is the wind in that door still?"
3 *O … Rag* Reference to a popular American ragtime song performed in Ziegfield's
 Follies in 1912.
4 [Eliot's note] Cf. the game of chess in Middleton's *Women Beware Women*.
5 *demobbed* Demobilized; released from military service.
6 *HURRY … TIME* Expression used by bartenders in Britain to announce closing
 time.

Now Albert's coming back, make yourself a bit smart.
He'll want to know what you done with that money he gave you
To get yourself some teeth. He did, I was there.
145 You have them all out, Lil, and get a nice set,
He said, I swear, I can't bear to look at you.
And no more can't I, I said, and think of poor Albert,
He's been in the army four years, he wants a good time,
And if you don't give it him, there's others will, I said.
150 Oh is there, she said. Something o' that, I said.
Then I'll know who to thank, she said, and give me a straight look.
Hurry up please its time
If you don't like it you can get on with it, I said.
Others can pick and choose if you can't.
But if Albert makes off, it won't be for lack of telling.
155 You ought to be ashamed, I said, to look so antique.
(And her only thirty-one.)
I can't help it, she said, pulling a long face,
It's them pills I took, to bring it off, she said.
(She's had five already, and nearly died of young George.)
160 The chemist° said it would be alright, but I've *pharmacist*
 never been the same.
You are a proper fool, I said.
Well, if Albert won't leave you alone, there it is, I said,
What you get married for if you don't want children?
Hurry up please its time
165 Well, that Sunday Albert was home, they had a hot
 gammon,° *smoked ham*
And they asked me in to dinner, to get the beauty
 of it hot—
Hurry up please its time
Hurry up please its time
Goonight Bill. Goonight Lou. Goonight May. Goonight.
170 Ta ta. Goonight. Goonight.
Good night, ladies, good night, sweet ladies, good night, good
 night.[1]

[1] *Good night … night* Ophelia's last words in Shakespeare's *Hamlet* (4.5.72–3) before
 she drowns herself. These words are taken by her father as evidence that she has been
 driven insane by Hamlet's seeming indifference to her.

3. THE FIRE SERMON[1]

The river's tent is broken: the last fingers of leaf
Clutch and sink into the wet bank. The wind
Crosses the brown land, unheard. The nymphs are departed. 175
Sweet Thames, run softly, till I end my song.[2]
The river bears no empty bottles, sandwich papers,
Silk handkerchiefs, cardboard boxes, cigarette ends
Or other testimony of summer nights. The nymphs are departed.
And their friends, the loitering heirs of city directors; 180
Departed, have left no addresses.
By the waters of Leman I sat down and wept ...[3]
Sweet Thames, run softly till I end my song,
Sweet Thames, run softly, for I speak not loud or long.
But at my back in a cold blast I hear 185
The rattle of the bones, and chuckle spread from ear to ear.[4]

A rat crept softly through the vegetation
Dragging its slimy belly on the bank
While I was fishing in the dull canal
On a winter evening round behind the gashouse 190
Musing upon the king my brother's wreck
And on the king my father's death before him.[5]
White bodies naked on the low damp ground

1 *The Fire Sermon* Sermon preached by the Buddha against passions (such as lust,
 anger, and envy) that consume people and prevent their regeneration.

2 *Sweet Thames ... song* Eliot's note cites the refrain of Edmund Spenser's *Prothala-
 mion* (1596), a poem that celebrates the ideals of marriage, written to commemorate
 the joint marriages of the two daughters of the Earl of Worcester.

3 *By the ... wept* Reference to Psalm 137, in which the Hebrews lament their exile in
 Babylon and their lost homeland of Jerusalem: "By the rivers of Babylon, there sat
 we down, yea, we wept, when we remembered Zion." For Babylon Eliot substitutes
 "Leman," the French name for Lake Geneva. "Leman" is also a medieval word mean-
 ing sweetheart.

4 *But at ... ear* Eliot's note cites Andrew Marvell's "To His Coy Mistress": "But at
 my back I always hear / Time's wingèd chariot hurrying near" (lines 21–22).

5 *And on ... him* Eliot's note cites Shakespeare's *The Tempest* 1.2.388–93, in which
 Ferdinand, shipwrecked on the shore, is prompted by Ariel's music to ponder the
 supposed drowning of his father, King Alonso: "Sitting on a bank, / Weeping again
 the king my father's wrack / This music crept by me upon the waters, / Allaying both
 their fury and my passion / With its sweet air." Eliot also quotes from this passage
 on line 257.

And bones cast in a little low dry garret,
195 Rattled by the rat's foot only, year to year.
But at my back from time to time I hear
The sound of horns and motors, which shall bring[1]
Sweeney[2] to Mrs. Porter in the spring.
O the moon shone bright on Mrs. Porter *[→ "commercial" type of tune; sing-songy]*
200 And on her daughter
They wash their feet in soda water[3]
Et O ces voix d'enfants, chantant dans la coupole![4]

Twit twit twit *[→ Philomel comes back; articulation vs. inarticulation]*
Jug jug jug jug jug jug
205 So rudely forc'd.
Tereu[5] *[can't quite say his name]*

Unreal City
Under the brown fog of a winter noon
Mr. Eugenides, the Smyrna[6] merchant *[→ "filthy rich Jew" stereotype]*
210 Unshaven, with a pocket full of currants
C.i.f. London: documents at sight,[7]

1 [Eliot's note] Cf. [John] Day, *Parliament of Bees*: "When of the sudden, listening, you shall hear, / A noise of horns and hunting, which shall bring / Actaeon to Diana in the spring, / Where all shall see her naked skin … " [According to classical myth, when the hunter Actaeon saw Diana, goddess of chastity and the hunt, bathing naked with her nymphs, she changed him into a stag and set his dogs upon him.] *[HA]*

2 *Sweeney* Character in two earlier poems by Eliot, "Sweeney Erect" and "Sweeney Among the Nightingales."

3 [Eliot's note] I do not know the origin of the ballad from which these are taken: it was reported to me from Sydney, Australia. [One version of this ballad, which was sung by Australian soldiers in World War I, is as follows: "O the moon shone bright on Mrs. Porter / And on the daughter / Of Mrs. Porter / They wash their feet in soda water / And so they oughter / To keep them clean."]

4 *Et O … coupole* French: "And O those children's voices singing under the cupola." Eliot's note indicates that this is the last line of French poet Paul Verlaine's sonnet "Parsifal" (1886). Verlaine refers to the opera *Parsifal* (1882) by Richard Wagner, in which a choir of children sings while the innocent knight Parsifal has his feet washed before entering the Castle of the Grail.

5 *Tereu* Latin vocative form of Tereus, who raped Philomela.

6 *Smyrna* Port city in western Turkey.

7 *C.i.f. … sight* Eliot's note explains that "C.i.f." means that the price includes "cost, insurance, freight to London," and that "documents on sight" indicates that "the Bill of Lading, etc., were to be handed to the buyer upon payment of the sight draft."

Asked me in demotic[1] French
To luncheon at the Cannon Street Hotel[2]
Followed by a weekend at the Metropole.[3]

At the violet hour, when the eyes and back 215
Turn upward from the desk, when the human engine waits
Like a taxi throbbing waiting,
I Tiresias,[4] though blind, throbbing between two lives,
Old man with wrinkled female breasts, can see
At the violet hour, the evening hour that strives 220
Homeward, and brings the sailor home from sea,[5]
The typist home at teatime, clears her breakfast, lights
Her stove, and lays out food in tins.
Out of the window perilously spread

1 *demotic* Popular; vulgar.
2 *Cannon Street Hotel* Hotel near the Cannon Street train station, a terminus for
 travelers to and from the continent.
3 *Metropole* Large hotel on the seashore at Brighton.
4 [Eliot's note] Tiresias, although a mere spectator and not indeed a "character,"
 is yet the most important personage in the poem, uniting all the rest. Just as the
 one-eyed merchant, seller of currants, melts into the Phoenician Sailor, and the
 latter is not wholly distinct from Ferdinand Prince of Naples, so all the women are
 one woman, and the two sexes meet in Tiresias. What Tiresias sees, in fact, is the
 substance of the poem. The whole passage from Ovid is of great anthropological
 interest. [Eliot then quotes in Latin the passage from *Metamorphoses* that describes
 Tiresias's sex change. Jove, who had drunk a great deal, "jested with Juno. He said,
 'Your pleasure in love is really greater than that enjoyed by men.' She denied it; so
 they decided to seek the opinion of the wise Tiresias, for he knew both aspects of
 love. For once, with a blow of his staff, he had committed violence on two huge
 snakes as they copulated in the green forest; and—wonderful to tell—was turned
 into a woman and thus spent seven years. In the eighth year he saw the same snakes
 again and said: 'If a blow struck at you is so powerful that it changes the sex of the
 giver, I will now strike at you again.' With these words she struck the snakes, and
 again became a man. So he was appointed arbiter in the playful quarrel, and sup-
 ported Jove's statement. It is said that Saturnia (Juno) was quite disproportionately
 upset, and condemned the arbiter to perpetual blindness. But the almighty father
 (for no god may undo what has been done by another god), in return for the sight
 that was taken away, gave him the power to know the future and so lightened the
 penalty paid by the honor."]
5 [Eliot's note] This may not appear as exact as Sappho's lines but I had in mind the
 "longshore" or "dory" fisherman, who returns at nightfall. [Eliot refers to seventh-
 century BCE Greek poet Sappho's poem, known as Fragment 149, in which Hes-
 perus, the evening star, brings home "all things the bright dawn disperses," including
 "the sheep, the goat, the child to its mother."]

225 Her drying combinations[1] touched by the sun's last rays,
On the divan are piled (at night her bed)
Stockings, slippers, camisoles, and stays.° *corset*
I Tiresias, old man with wrinkled dugs° *breasts*
Perceived the scene, and foretold the rest—
230 I too awaited the expected guest.
He, the young man carbuncular,° arrives, *pimply*
A small house agent's clerk, with one bold stare,
One of the low on whom assurance sits
As a silk hat on a Bradford[2] millionaire.
235 The time is now propitious, as he guesses,
The meal is ended, she is bored and tired,
Endeavours to engage her in caresses
Which still are unreproved, if undesired.
Flushed and decided, he assaults at once;
240 Exploring hands encounter no defence;
His vanity requires no response,
And makes a welcome of indifference.
(And I Tiresias have foresuffered all
Enacted on this same divan or bed;
245 I who have sat by Thebes below the wall
And walked among the lowest of the dead.)[3]
Bestows one final patronising kiss,
And gropes his way, finding the stairs unlit …
She turns and looks a moment in the glass,
250 Hardly aware of her departed lover;
Her brain allows one half-formed thought to pass:
"Well now that's done: and I'm glad it's over."

1 *combinations* Undergarments that combined the chemise and panties.
2 *Bradford* Textile center in industrial Yorkshire, many of whose residents became
 extremely wealthy during the textile boom that accompanied World War I.
3 *I who … dead* In *Oedipus Rex*, by fifth-century BCE Greek dramatist Sophocles,
 Tiresias perceives that the curse of infertility plaguing the people and land of Thebes
 has been brought upon them by the unwitting marriage of Oedipus to his mother,
 Queen Jocasta. In book 9 of Homer's *Odyssey*, Odysseus journeys to the underworld,
 where he consults Tiresias.

When lovely woman stoops to folly and[1]
Paces about her room again, alone,
She smoothes her hair with automatic hand, → discordia concors 255
And puts a record on the gramophone.

→ background noise; automatic

"This music crept by me upon the waters"[2]
And along the Strand, up Queen Victoria Street.
O City city, I can sometimes hear
Beside a public bar in Lower Thames Street, 260
The pleasant whining of a mandoline
And a clatter and a chatter from within
Where fishmen lounge at noon: where the walls
Of Magnus Martyr[3] hold
Inexplicable splendour of Ionian white and gold.[4] 265

　　　The river sweats[5]
　　　Oil and tar
　　　The barges drift
　　　With the turning tide
　　　Red sails 270
　　　Wide
　　　To leeward, swing on the heavy spar.
　　　The barges wash
　　　Drifting logs
　　　Down Greenwich reach 275

1　When ... and　Eliot's note cites Oliver Goldsmith's novel *The Vicar of Wakefield*
　(1762), in which Olivia, returning to the place where she was seduced, sings: "When
　lovely woman stoops to folly / And finds too late that men betray / What charm can
　soothe her melancholy, / What art can wash her guilt away? / The only art her guilt
　to cover, / To hide her shame from every eye, / To give repentance to her lover, / And
　wring his bosom—is to die."
2　[Eliot's note]　V. [I.e., "see," from the Latin *vide*.] *The Tempest*, as above.
3　[Eliot's note]　The interior of St. Magnus Martyr is to my mind one of the finest
　among [Sir Christopher] Wren's interiors. See *The Proposed Demolition of Nineteen
　City Churches* (P.S. King & Son, Ltd.).
4　*Inexplicable ... gold*　Reference to the slender Ionic columns inside the church.
5　[Eliot's note]　The Song of the (three) Thames-daughters begins here. From line
　292 to 306 inclusive they speak in turn. V. *Gotterdammerung*, 3.1: the Rhine-daugh-
　ters. [Eliot refers to Wagner's opera *The Twilight of the Gods*, in which the Rhine
　maidens lament the theft of the Rhine's gold, which has also robbed the river of its
　beauty.]

Past the Isle of Dogs.[1]
　　　Weialala leia
　　　Wallala leialala[2]

　　　Elizabeth and Leicester[3]
280　　Beating oars
　　　The stern was formed
　　　A gilded shell
　　　Red and gold
　　　The brisk swell
285　　Rippled both shores
　　　Southwest wind
　　　Carried down stream
　　　The peal of bells
　　　White towers
290　　Weialala leia
　　　Wallala leialala

"Trams and dusty trees.
Highbury bore me. Richmond and Kew
Undid me. By Richmond I raised my knees
295　Supine on the floor of a narrow canoe."[4]

1　*Isle of Dogs*　Peninsula formed by a bend in the river Thames. Opposite this penin-
　　sula, on the south side of the Thames, lies the London borough of Greenwich.

2　*Weialala ... leialala*　In Wagner's opera, this is the ecstatic cry repeated by the
　　maidens as they guard the lump of gold in the river.

3　[Eliot's note]　V. Froude, *Elizabeth*, Vol. 1, ch. 4, letter of De Quadra to Philip of
　　Spain:

　　　　In the afternoon we were in a barge, watching the games on the river. (The
　　　　queen) was alone with Lord Robert and myself on the poop, when they
　　　　began to talk nonsense, and went so far that Lord Robert at last said, as I was
　　　　on the spot there was no reason why they should not be married if the queen
　　　　pleased. [Eliot refers to *History of England from the Fall of Wolsey to the Death
　　　　of Elizabeth* (1856–70), by James Anthony Froude. Froude quotes from a
　　　　letter by Alvarez de Quadra, Bishop of Aquila and Spanish Ambassador to
　　　　Queen Elizabeth's court. De Quadra believed the young Queen would marry
　　　　Lord Robert Dudley (the Earl of Leicester).]

4　*Trams and ... canoe*　Eliot's note cites the lines from Dante's *Purgatorio* (5.130–36)
　　that he parodies: "Remember me, who am La Pia [Piety]; / Sienna made me and the
　　Maremma undid me"; *Highbury* Middle-class suburb in north London; *Richmond
　　and Kew* Areas of London located on the Thames in southwest London. Between
　　them lies Kew Gardens.

"My feet are at Moorgate,[1] and my heart
Under my feet. After the event
He wept. He promised 'a new start.'
I made no comment. What should I resent?"

"On Margate Sands.[2] *"do you know nothing?" earlier* 300
I can connect
Nothing with nothing.
The broken fingernails of dirty hands.
My people humble people who expect
Nothing." *making slaves think they're free so* 305
 la la *they don't know they're slaves*

To Carthage then I came[3]

Burning burning burning burning[4]
O Lord Thou pluckest me out[5]
O Lord Thou pluckest 310

burning → *were we cleansed by Fire Sermon?*

4. DEATH BY WATER → *Madame Sosostris*

Phlebas the Phoenician, a fortnight dead,
Forgot the cry of gulls, and the deep sea swell

1 *Moorgate* Area in the east of the City.
2 *Margate Sands* Primary beach in the Kent seaside resort of Margate.
3 *To Carthage … came* Eliot's note cites the opening of Book 3 of *The Confessions of Saint Augustine*: "To Carthage then I came, where a cauldron of unholy loves sang all about mine ears."
4 [Eliot's note] The complete text of the Buddha's Fire Sermon (which corresponds in importance to the Sermon on the Mount) from which these words are taken, will be found translated in the late Henry Clarke Warren's *Buddhism in Translation* (Harvard Oriental Series). Mr. Warren was one of the great pioneers of Buddhist studies in the Occident.
5 [Eliot's note] From St. Augustine's *Confessions* again. The collocation of these two representatives of eastern and western asceticism, as the culmination of this part of the poem, is not an accident. [Eliot refers to 10.237–38 of the Confessions: "I entangle my steps with these outward beauties, but thou pluckest me out, O Lord, thou pluckest me out."]

And the profit and loss.

315 A current under sea

Picked his bones in whispers. As he rose and fell

He passed the stages of his age and youth

Entering the whirlpool. → *drowning ; how curious*

 Gentile or Jew

320 O you who turn the wheel and look to windward,

Consider Phlebas, who was once handsome and tall as you.

... but he, too, died

5. WHAT THE THUNDER SAID[1]

After the torchlight red on sweaty faces

After the frosty silence in the gardens

After the agony in stony places

325 The shouting and the crying

Prison and palace and reverberation

Of thunder of spring over distant mountains

He who was living is now dead[2]

We who were living are now dying

330 With a little patience

Here is no water but only rock

Rock and no water and the sandy road

The road winding above among the mountains

Which are mountains of rock without water

335 If there were water we should stop and drink

Amongst the rock one cannot stop or think

Sweat is dry and feet are in the sand

If there were only water amongst the rock

Dead mountain mouth of carious[3] teeth that cannot spit

1 [Eliot's note] In the first part of Part 5 three themes are employed: the journey to Emmaus, the approach to the Chapel Perilous (see Miss Weston's book), and the present decay of eastern Europe. [*journey to Emmaus* See Luke 24.13–31, in which Jesus, after being resurrected, joins two of his disciples on the road to Emmaus, but they do not recognize him; *Chapel Perilous* The final stage of the Grail quest.]

2 *After the torchlight ... dead* References to the events from the betrayal of Christ to His death.

3 *carious* Decayed.

Here one can neither stand nor lie nor sit 340
There is not even silence in the mountains
But dry sterile thunder without rain
There is not even solitude in the mountains
But red sullen faces sneer and snarl
From doors of mudcracked houses 345
 If there were water

 And no rock → *anadiplosis; cyclicale;*
 If there were rock *adding to) desparation*
 And also water
 And water 350
 A spring
 A pool among the rock
 If there were the sound of water only
 Not the cicada[1]
 And dry grass singing 355
 But sound of water over a rock
 Where the hermit-thrush sings in the pine trees[2]
 Drip drop drip drop drop drop drop
 But there is no water → *always wanting .*

Who is the third who walks always beside you?[3] 360
When I count, there are only you and I together

1 *cicada* Grasshopper. See Ecclesiastes 12.4: "Also when they shall be afraid of that
 which is high, and fears shall be in the way, and the almond tree shall flourish, and
 the grasshopper shall be a burden, and desire shall fail: because man goeth to his
 long home, and the mourners go about the streets."

2 [Eliot's note] This is *Turdus aonalaschkae pallasii,* the hermit-thrush which I have
 heard in Quebec Province. Chapman says (*Handbook of Birds of Eastern North
 America*) "it is most at home in secluded woodland and thickety retreats.... Its
 notes are not remarkable for variety or volume, but in purity and sweetness of tone
 and exquisite modulation they are unequalled." Its "water-dripping song" is justly
 celebrated.

3 [Eliot's note] The following lines were stimulated by the account of one of the
 Antarctic expeditions (I forget which, but I think one of Shackleton's): it was related
 that the party of explorers, at the extremity of their strength, had the constant delu-
 sion that there was *one more member* than could actually be counted. [Eliot refers to
 Sir Ernest Shackleton's third journey to the Antarctic (1914–17), during which he
 and his men attempted to cross the Antarctic ice cap on foot. See *South: The Story of
 Shackleton's Last Expedition, 1914-1917* (1919).]

But when I look ahead up the white road
There is always another one walking beside you
Gliding wrapt in a brown mantle, hooded
365 I do not know whether a man or a woman
—But who is that on the other side of you?

What is that sound high in the air
Murmur of maternal lamentation
Who are those hooded hordes swarming
370 Over endless plains, stumbling in cracked earth
Ringed by the flat horizon only
What is the city over the mountains
Cracks and reforms and bursts in the violet air
Falling towers
375 Jerusalem Athens Alexandria → *everywhere is like this*
Vienna London
Unreal[1] — *dreams*

A woman drew her long black hair out tight
And fiddled whisper music on those strings
380 And bats with baby faces in the violet light → *creepy yet*
Whistled, and beat their wings *childish*
And crawled head downward down a blackened wall
And upside down in air were towers
Tolling reminiscent bells, that kept the hours
385 And voices singing out of empty cisterns and exhausted wells.

In this decayed hole among the mountains
In the faint moonlight, the grass is singing
Over the tumbled graves, about the chapel

1 *What is that ... unreal* Eliot's note for these lines quotes in German Herman
Hesse, *Blick ins Chaos: Drei Aufsätze* (*A Glimpse into Chaos: Three Essays*). "Already
half of Europe, already at least half of Eastern Europe, on the way to chaos, drives
drunk in sacred infatuation along the edge of the precipice, singing drunkenly, as
though singing hymns, as Dmitri Karamazov sang. The offended bourgeois laughs
at the songs; the saint and the seer hear them with tears." Dmitri Karamazov is a
character in Fyodor Dostoevsky's *The Brothers Karamazov* (1879–80).

There is the empty chapel, only the wind's home.[1]
It has no windows, and the door swings, 390
Dry bones can harm no one.
Only a cock stood on the rooftree
Co co rico co co rico[2]
In a flash of lightning. Then a damp gust
Bringing rain 395

Ganga[3] was sunken, and the limp leaves
Waited for rain, while the black clouds
Gathered far distant, over Himavant.[4]
The jungle crouched, humped in silence.
Then spoke the thunder 400
DA[5]
Datta: what have we given?
My friend, blood shaking my heart
The awful daring of a moment's surrender
Which an age of prudence can never retract 405
By this, and this only, we have existed
Which is not to be found in our obituaries

1 *There is ... home* The Chapel Perilous appeared to be surrounded by death and decay; these nightmare visions were meant to induce despair in the questing knight. Once inside the Chapel, the knight's courage would be tested with further horrors.

2 *Only a ... rico* The crowing of the cock signals the coming of the morning and the departure of ghosts and evil spirits, as in *Hamlet* 1.1, when Hamlet's father's ghost disappears with its call. Also, in the Gospels Peter repents his repudiation of Christ after the cock crows.

3 *Ganga* The Ganges, a sacred river in India.

4 *Himavant* Sanskrit: snowy. Adjective used to describe the Himalayas.

5 [Eliot's note] "Datta, dayadhvam, damyata" (Give, sympathise, control). The fable of the meaning of the Thunder is found in the *Brihadaranyaka—Upanishad*, 5, 1. A translation is found in Deussen's *Sechzig Upanishads des Veda,* p. 489. [Eliot refers to the Hindu fable in which gods, men, and demons, each in turn, ask the Lord of Creation, Prajapati, "Please instruct us, Sir." To each he utters the syllable "Da," and each group interprets the answer differently: "Damyata," practice self-control; "Datta," give alms; "Dayadhvam," have compassion. According to the fable, "This very thing is repeated even today by the heavenly voice, in the form of thunder, as 'Da,' 'Da,' 'Da,' which means: 'Control yourselves,' 'Give,' and 'Have compassion.'"]

Or in memories draped by the beneficent spider[1]
Or under seals broken by the lean solicitor
410 In our empty rooms
Dᴀ
Dayadhvam: I have heard the key[2]
Turn in the door once and turn once only
We think of the key, each in his prison
415 Thinking of the key, each confirms a prison
Only at nightfall, aetherial rumours
Revive for a moment a broken Coriolanus[3]
Dᴀ *→ must control ourselves*
Damyata: The boat responded
420 Gaily, to the hand expert with sail and oar
The sea was calm, your heart would have responded
Gaily, when invited, beating obedient
To controlling hands

Fisher king I sat upon the shore *"The Waste Land"*
425 Fishing, with the arid plain behind me[4] →

→ Shakespeare's contemporary

1 [Eliot's note] Cf. [John] Webster, *The White Devil*, 5, 6: "... they'll remarry / Ere the worm pierce your winding-sheet, ere the spider / Make a thin curtain for your epitaphs." [In this excerpt from the play, the villain Flamineo urges men never to trust their wives.]

2 *I have ... key* Eliot's note cites the passage in Dante's *Inferno* 33.46, in which Ugolino della Gherardesca remembers being locked up with his children in the tower, where they all starved to death. Eliot also quotes philosopher Francis Herbert Bradley's *Appearance and Reality: A Metaphysical Essay* (1893), p. 346: "My external sensations are no less private to myself than are my thoughts or my feelings. In either case my experience falls within my own circle, a circle closed on the outside; and, with all its elements alike, every sphere is opaque to the others which surround it.... In brief, regarded as an existence which appears in a soul, the whole world for each is peculiar and private to that soul."

3 *Coriolanus* Roman general of Shakespeare's play of that name. A character who is motivated by pride rather than duty, Coriolanus leads the enemy against Rome, the city from which he has been exiled.

4 *Fishing ... me* Eliot's note refers readers to Weston's *From Ritual to Romance*, chapter 9, "The Fisher King." In this chapter, Weston comments upon the Fisher King's intimate relation with his people and his land, "a relation mainly dependent upon the identification of the King with the Divine principle of Life and Fertility." Weston also argues that "the Fish is a Life symbol of immemorial antiquity, and that the title of Fisher has, from the earliest ages, been associated with Deities who were held to be specially connected with the origin and preservation of life."

Shall I at least set my lands in order?[1]
London Bridge is falling down falling down falling down
Poi s'ascose nel foco che gli affina[2]
Quando fiam ceu chelidon[3]—O swallow swallow
Le Prince d'Aquitaine à la tour abolie[4]
These fragments I have shored against my ruins
Why then Ile fit you. Hieronymo's mad againe.[5]
Datta. Dayadhvam. Damyata.
 Shantih shantih shantih[6]

—1922

1 *Shall I ... order* See Isaiah 38.1, in which the prophet Isaiah counsels the sickly
 King Hezekiah, whose kingdom has been destroyed by the conquering Assyrians,
 "Thus saith the Lord, Set thine house in order: for thou shalt die, and not live."

2 *Poi ... affina* Italian: "Then he vanished into the fire that refines them" (Dante's
 Purgatorio 26.148). Eliot's note quotes, in Italian, the three lines of the *Purgatorio*
 immediately preceding, in which the poet Arnaut Daniel, who is in Purgatory for
 lust, says to Dante, "Now I pray you, by the goodness that guides you to the top of
 the staircase [of purgatory], be mindful in time of my suffering."

3 *Quando ... chelidon* Latin: "When shall I be as the swallow?" Eliot's note cites an
 anonymous Latin poem about Venus and the spring, "The Vigil of Venus," as well
 as the story of Philomela, whose sister Procne (the wife of Tereus) was turned into a
 swallow. "The Vigil of Venus" refers to Philomela and Procne in its closing lines.

4 *Le Prince ... abolie* French: "The Prince of Aquitaine in the ruined tower." Eliot's
 note cites French poet Gerard de Nerval's sonnet "El Desdichado" (1853). One of
 the Tarot cards shows a tower struck by lightning.

5 *Why then ... againe* Eliot's note cites Thomas Kyd's *The Spanish Tragedy: Hier-
 onymo Is Mad Againe* (1592). In the play, Hieronymo, whose son has been mur-
 dered, is asked to write a play for the court. He responds "Why then Ile fit you"
 (i.e., "I'll accommodate you," or "I'll give you your due"). He writes the play and
 persuades the murderers to act in it. During the course of the play, his son's murder
 is avenged.

6 [Eliot's note] Shantih. Repeated as here, a formal ending to an Upanishad. "The
 Peace which passeth understanding" is our equivalent to this word. [The Upanishads
 are poetic dialogues that comment on the Vedas, the ancient Hindu Scriptures.
 Eliot's phrasing derives from Paul's letter to the early Christians in Philippians 4.7:
 "And the peace of God, which passeth all understanding, shall keep your hearts and
 minds through Jesus Christ."]

Tradition and the Individual Talent

I

In English writing we seldom speak of tradition, though we occasionally apply its name in deploring its absence. We cannot refer to "the tradition" or to "a tradition"; at most, we employ the adjective in saying that the poetry of So-and-so is "traditional" or even "too traditional." Seldom, perhaps, does the word appear except in a phrase of censure. If otherwise, it is vaguely approbative, with the implication, as to the work approved, of some pleasing archaeological reconstruction. You can hardly make the word agreeable to English ears without this comfortable reference to the reassuring science of archaeology.

Certainly the word is not likely to appear in our appreciations of living or dead writers. Every nation, every race, has not only its own creative, but its own critical turn of mind; and is even more oblivious of the shortcomings and limitations of its critical habits than of those of its creative genius. We know, or think we know, from the enormous mass of critical writing that has appeared in the French language, the critical method or habit of the French; we only conclude (we are such unconscious people) that the French are "more critical than we," and sometimes even plume ourselves a little with the fact, as if the French were the less spontaneous. Perhaps they are; but we might remind ourselves that criticism is as inevitable as breathing, and that we should be none the worse for articulating what passes in our minds when we read a book and feel an emotion about it, for criticizing our own minds in their work of criticism. One of the facts that might come to light in this process is our tendency to insist, when we praise a poet, upon those aspects of his work in which he least resembles anyone else. In these aspects or parts of his work we pretend to find what is individual, what is the peculiar essence of the man. We dwell with satisfaction upon the poet's difference from his predecessors, especially his immediate predecessors; we endeavour to find something that can be isolated in order to be enjoyed. Whereas if we approach a poet without this prejudice we shall often find that not only the best, but the most individual parts of his work may be those in which the dead poets, his ancestors, assert

their immortality most vigorously. And I do not mean the impressionable period of adolescence, but the period of full maturity.

Yet if the only form of tradition, of handing down, consisted in following the ways of the immediate generation before us in a blind or timid adherence to its successes, "tradition" should positively be discouraged. We have seen many such simple currents soon lost in the sand; and novelty is better than repetition. Tradition is a matter of much wider significance. It cannot be inherited, and if you want it you must obtain it by great labour. It involves, in the first place, the historical sense, which we may call nearly indispensable to anyone who would continue to be a poet beyond his twenty-fifth year; and the historical sense involves a perception, not only of the pastness of the past, but of its presence; the historical sense compels a man to write not merely with his own generation in his bones, but with a feeling that the whole of the literature of Europe from Homer[1] and within it the whole of the literature of his own country has a simultaneous existence and composes a simultaneous order. This historical sense, which is a sense of the timeless as well as of the temporal and of the timeless and of the temporal together, is what makes a writer traditional. And it is at the same time what makes a writer most acutely conscious of his place in time, of his own contemporaneity.

No poet, no artist of any art, has his complete meaning alone. His significance, his appreciation is the appreciation of his relation to the dead poets and artists. You cannot value him alone; you must set him, for contrast and comparison, among the dead. I mean this as a principle of aesthetic, not merely historical, criticism. The necessity that he shall conform, that he shall cohere, is not one-sided; what happens when a new work of art is created is something that happens simultaneously to all the works of art which preceded it. The existing monuments form an ideal order among themselves, which is modified by the introduction of the new (the really new) work of art among them. The existing order is complete before the new work arrives; for order to persist after the supervention of novelty, the *whole* existing order must be, if ever so slightly, altered; and so the relations, proportions, values of each work of art toward the whole are readjusted; and this is

1 *Homer* Greek poet (c. 700 BCE), author of the *Iliad* and the *Odyssey*.

conformity between the old and the new. Whoever has approved this idea of order, of the form of European, of English literature will not find it preposterous that the past should be altered by the present as much as the present is directed by the past. And the poet who is aware of this will be aware of great difficulties and responsibilities.

In a peculiar sense he will be aware also that he must inevitably be judged by the standards of the past. I say judged, not amputated, by them; not judged to be as good as, or worse or better than, the dead; and certainly not judged by the canons of dead critics. It is a judgement, a comparison, in which two things are measured by each other. To conform merely would be for the new work not really to conform at all; it would not be new, and would therefore not be a work of art. And we do not quite say that the new is more valuable because it fits in; but its fitting in is a test of its value—a test, it is true, which can only be slowly and cautiously applied, for we are none of us infallible judges of conformity. We say: it appears to conform, and is perhaps individual, or it appears individual, and may conform; but we are hardly likely to find that it is one and not the other.

To proceed to a more intelligible exposition of the relation of the poet to the past: he can neither take the past as a lump, an indiscriminate bolus,[1] nor can he form himself wholly on one or two private admirations, nor can he form himself wholly upon one preferred period. The first course is inadmissible, the second is an important experience of youth, and the third is a pleasant and highly desirable supplement. The poet must be very conscious of the main current, which does not at all flow invariably through the most distinguished reputations. He must be quite aware of the obvious fact that art never improves, but that the material of art is never quite the same. He must be aware that the mind of Europe—the mind of his own country—a mind which he learns in time to be much more important than his own private mind—is a mind which changes, and that this change is a development which abandons nothing *en route*, which does not superannuate either Shakespeare, or Homer, or the rock drawing of the Magdalenian

1 *bolus* Round mass.

draughtsmen.[1] That this development, refinement perhaps, complication certainly, is not, from the point of view of the artist, any improvement. Perhaps not even an improvement from the point of view of the psychologist or not to the extent which we imagine; perhaps only in the end based upon a complication in economics and machinery. But the difference between the present and the past is that the conscious present is an awareness of the past in a way and to an extent which the past's awareness of itself cannot show.

Someone said: "The dead writers are remote from us because we *know* so much more than they did." Precisely, and they are that which we know.

I am alive to a usual objection to what is clearly part of my programme for the *métier* of poetry. The objection is that the doctrine requires a ridiculous amount of erudition (pedantry), a claim which can be rejected by appeal to the lives of poets in any pantheon. It will even be affirmed that much learning deadens or perverts poetic sensibility. While, however, we persist in believing that a poet ought to know as much as will not encroach upon his necessary receptivity and necessary laziness, it is not desirable to confine knowledge to whatever can be put into a useful shape for examinations, drawing rooms, or the still more pretentious modes of publicity. Some can absorb knowledge, the more tardy must sweat for it. Shakespeare acquired more essential history from Plutarch[2] than most men could from the whole British Museum. What is to be insisted upon is that the poet must develop or procure the consciousness of the past and that he should continue to develop this consciousness throughout his career.

What happens is a continual surrender of himself as he is at the moment to something which is more valuable. The progress of an artist is a continual self-sacrifice, a continual extinction of personality.

There remains to define this process of depersonalization and its relation to the sense of tradition. It is in this depersonaliza-

1 *Magdalenian draughtsmen* Magdalenian cave paintings of the Paleolithic period are among the first known works of art.

2 *Plutarch* Greek biographer of the first century CE who strongly influenced English literature; Shakespeare drew some of his characters in plays such as *Coriolanus, Antony and Cleopatra,* and *Julius Caesar* from Plutarch's biographies.

tion that art may be said to approach the condition of science. I therefore invite you to consider, as a suggestive analogy, the action which takes place when a bit of finely filiated[1] platinum is introduced into a chamber containing oxygen and sulphur dioxide.

2

Honest criticism and sensitive appreciation is directed not upon the poet but upon the poetry. If we attend to the confused cries of the newspaper critics and the susurrus[2] of popular repetition that follows, we shall hear the names of poets in great numbers; if we seek not Blue-book[3] knowledge but the enjoyment of poetry, and ask for a poem, we shall seldom find it. I have tried to point out the importance of the relation of the poem to other poems by other authors, and suggested the conception of poetry as a living whole of all the poetry that has ever been written. The other aspect of this Impersonal theory of poetry is the relation of the poem to its author. And I hinted, by an analogy, that the mind of the mature poet differs from that of the immature one not precisely in any valuation of "personality," not being necessarily more interesting, or having "more to say," but rather by being a more finely perfected medium in which special, or very varied, feelings are at liberty to enter into new combinations.

The analogy was that of the catalyst. When the two gases previously mentioned are mixed in the presence of a filament of platinum, they form sulphurous acid. This combination takes place only if the platinum is present; nevertheless, the newly formed acid contains no trace of platinum, and the platinum itself is apparently unaffected: has remained inert, neutral, and unchanged. The mind of the poet is the shred of platinum. It may partly or exclusively operate upon the experience of the man himself; but, the more perfect the artist, the more completely separate in him will be the man who suffers and the mind which creates; the more perfectly will the mind digest and transmute the passions which are its material.

1 *filiated* Made into filament, or fine thread.
2 *susurrus* Whispering or muttering.
3 *Blue-book* Official reports of the British Government.

T.S. ELIOT

The experience, you will notice, the elements which enter the presence of the transforming catalyst, are of two kinds: emotions and feelings. The effect of a work of art upon the person who enjoys it is an experience different in kind from any experience not of art. It may be formed out of one emotion, or may be a combination of several; and various feelings, inhering for the writer in particular words or phrases or images, may be added to compose the final result. Or great poetry may be made without the direct use of any emotion whatever: composed out of feelings solely. Canto XV of the *Inferno*[1] (Brunetto Latini) is a working up of the emotion evident in the situation; but the effect, though single as that of any work of art, is obtained by considerable complexity of detail. The last quatrain gives an image, a feeling attaching to an image, which "came," which did not develop simply out of what precedes, but which was probably in suspension in the poet's mind until the proper combination arrived for it to add itself to. The poet's mind is in fact a receptacle for seizing and storing up numberless feelings, phrases, images, which remain there until all the particles which can unite to form a new compound are present together.

If you compare several representative passages of the greatest poetry you see how great is the variety of types of combination, and also how completely any semi-ethical criterion of "sublimity" misses the mark. For it is not the "greatness," the intensity, of the emotions, the components, but the intensity of the artistic process, the pressure, so to speak, under which the fusion takes place, that counts. The episode of Paolo and Francesca[2] employs a definite emotion, but the intensity of the poetry is something quite different from whatever intensity in the supposed experience it may give the impression of. It is no more intense, furthermore, than Canto XXVI, the voyage of Ulysses, which has not the direct dependence upon an emotion. Great variety is possible in the process of transmutation of emotion: the murder

1 *Canto XV of the Inferno* In this canto, Dante meets an old acquaintance, Brunetto Latini, who is in Hell for being a Sodomite.

2 *episode of Paolo and Francesca* Two illicit lovers (Paolo is Francesca's husband's brother).

of Agamemnon,[1] or the agony of Othello,[2] gives an artistic effect apparently closer to a possible original than the scenes from Dante. In the *Agamemnon,* the artistic emotion approximates to the emotion of an actual spectator; in *Othello* to the emotion of the protagonist himself. But the difference between art and the event is always absolute; the combination which is the murder of Agamemnon is probably as complex as that which is the voyage of Ulysses. In either case there has been a fusion of elements. The ode of Keats contains a number of feelings which have nothing particular to do with the nightingale, but which the nightingale, partly perhaps because of its attractive name, and partly because of its reputation, served to bring together.

The point of view which I am struggling to attack is perhaps related to the metaphysical theory of the substantial unity of the soul: for my meaning is, that the poet has, not a "personality" to express, but a particular medium, which is only a medium and not a personality, in which impressions and experiences combine in peculiar and unexpected ways. Impressions and experiences which are important for the man may take no place in the poetry, and those which become important in the poetry may play quite a negligible part in the man, the personality.

I will quote a passage which is unfamiliar enough to be regarded with fresh attention in the light—or darkness—of these observations:

> And now methinks I could e'en chide myself
> For doting on her beauty, though her death
> Shall be revenged after no common action.
> Does the silkworm expend her yellow labours
> For thee? For thee does she undo herself?
> Are lordships sold to maintain ladyships
> For the poor benefit of a bewildering minute?
> Why does yon fellow falsify highways,
> And put his life between the judge's lips,

1 *murder of Agamemnon* In Aeschylus's play, Clytemnestra kills her husband Agamemnon after he sacrifices their daughter to the god Artemis.
2 *agony of Othello* In the play by Shakespeare, Othello mistakenly thinks that his wife is unfaithful, kills her, and then, upon learning the truth, commits suicide.

To refine such a thing—keeps horse and men
To beat their valours for her?...[1]

In this passage (as is evident if it is taken in its context) there is a combination of positive and negative emotions: an intensely strong attraction toward beauty and an equally intense fascination by the ugliness which is contrasted with it and which destroys it. This balance of contrasted emotion is in the dramatic situation to which the speech is pertinent, but that situation alone is inadequate to it. This is, so to speak, the structural emotion, provided by the drama. But the whole effect, the dominant tone, is due to the fact that a number of floating feelings, having an affinity to this emotion by no means superficially evident, have combined with it to give us a new art emotion.

It is not in his personal emotions, the emotions provoked by particular events in his life, that the poet is in anyway remarkable or interesting. His particular emotions may be simple, or crude, or flat. The emotion in his poetry will be a very complex thing, but not with the complexity of the emotions of people who have very complex or unusual emotions in life. One error, in fact, of eccentricity in poetry is to seek for new human emotions to express; and in this search for novelty in the wrong place it discovers the perverse. The business of the poet is not to find new emotions, but to use the ordinary ones and, in working them up into poetry, to express feelings which are not in actual emotions at all. And emotions which he has never experienced will serve his turn as well as those familiar to him. Consequently, we must believe that "emotion recollected in tranquillity"[2] is an inexact formula. For it is neither emotion, nor recollection, nor, without distortion of meaning, tranquillity. It is a concentration, and a new thing resulting from the concentration, of a very great number of

1 *And now ... for her* From *The Revenger's Tragedy* (1607), a play variously ascribed to Cyril Tourneur and to Thomas Middleton.

2 *"emotion ... tranquillity"* From William Wordsworth's Preface to *Lyrical Ballads* (1800): "Poetry is the spontaneous overflow of powerful feelings: it takes its origin from emotion recollected in tranquillity: the emotion is contemplated till by a species of reaction the tranquillity gradually disappears, and an emotion, kindred to that which was before the subject of contemplation, is gradually produced, and does itself actually exist in the mind."

experiences which to the practical and active person would not seem to be experiences at all; it is a concentration which does not happen consciously or of deliberation. These experiences are not "recollected," and they finally unite in an atmosphere which is "tranquil" only in that it is a passive attending upon the event. Of course this is not quite the whole story. There is a great deal, in the writing of poetry, which must be conscious and deliberate. In fact, the bad poet is usually unconscious where he ought to be conscious, and conscious where he ought to be unconscious. Both errors tend to make him "personal." Poetry is not a turning loose of emotion, but an escape from emotion; it is not the expression of personality, but an escape from personality. But, of course, only those who have personality and emotions know what it means to want to escape from these things.

3
ὁ δὲ νοῦς ἰοως θειότερόν τι καὶ ἀπαθές ἐστιν[1]

This essay proposes to halt at the frontier of metaphysics or mysticism, and confine itself to such practical conclusions as can be applied by the responsible person interested in poetry. To divert interest from the poet to the poetry is a laudable aim: for it would conduce to a juster estimation of actual poetry, good and bad. There are many people who appreciate the expression of sincere emotion in verse, and there is a smaller number of people who can appreciate technical excellence. But very few know when there is an expression of *significant* emotion, emotion which has its life in the poem and not in the history of the poet. The emotion of art is impersonal. And the poet cannot reach this impersonality without surrendering himself wholly to the work to be done. And he is not likely to know what is to be done unless he lives in what is not merely the present, but the present moment of the past, unless he is conscious, not of what is dead, but of what is already living.

—1919

1 ὁ δὲ … ἐστιν Greek: "The mind is doubtless something more divine and unaffected." From Aristotle's *De Anima* (Latin: On the Soul) 1.4.

The Metaphysical Poets[1]

B y collecting these poems from the work of a generation more often named than read, and more often read than profitably studied, Professor Grierson has rendered a service of some importance. Certainly the reader will meet with many poems already preserved in other anthologies, at the same time that he discovers poems such as those of Aurelian Townshend or Lord Herbert of Cherbury here included. But the function of such an anthology as this is neither that of Professor Saintsbury's admirable edition of Caroline poets nor that of *The Oxford Book of English Verse*. Mr. Grierson's book is in itself a piece of criticism, and a provocation of criticism; and we think that he was right in including so many poems of Donne, elsewhere (though not in many editions) accessible, as documents in the case of "metaphysical poetry." The phrase has long done duty as a term of abuse, or as the label of a quaint and pleasant taste. The question is to what extent the so-called metaphysicals formed a school (in our own time we should say a "movement"), and how far this so-called school or movement is a digression from the main current.

Not only is it extremely difficult to define metaphysical poetry, but difficult to decide what poets practise it and in which of their verses. The poetry of Donne (to whom Marvell and Bishop King are sometimes nearer than any of the other authors) is late Elizabethan, its feeling often very close to that of Chapman. The "courtly" poetry is derivative from Jonson, who borrowed liberally from the Latin; it expires in the next century with the sentiment and witticism of Prior. There is finally the devotional verse of Herbert, Vaughan, and Crashaw (echoed long after by Christina Rossetti and Francis Thompson); Crashaw, sometimes more profound and less sectarian than the others, has a quality which returns through the Elizabethan period to the early Italians. It is difficult to find any precise use of metaphor, simile, or other conceit, which is common to all the poets and at the same time important enough as an element of style to isolate these poets

1 *The Metaphysical Poets* Originally published in the *Times Literary Supplement* as a review of the Clarendon Press volume *Metaphysical Lyrics and Poems of the Seventeenth Century: Donne to Butler* (1921), edited by Herbert J.C. Grierson.

as a group. Donne, and often Cowley, employ a device which is sometimes considered characteristically "metaphysical"; the elaboration (contrasted with the condensation) of a figure of speech to the furthest stage to which ingenuity can carry it. Thus Cowley develops the commonplace comparison of the world to a chessboard through long stanzas ("To Destiny"),[1] and Donne, with more grace, in "A Valediction,"[2] the comparison of two lovers to a pair of compasses. But elsewhere we find, instead of the mere explication of the content of a comparison, a development by rapid association of thought which requires considerable agility on the part of the reader.

> *On a round ball*
> *A workeman that hath copies by, can lay*
> *An Europe, Afrique, and an Asia,*
> *And quickly make that, which was nothing, All,*
> > *So doth each teare,*
> > *Which thee doth weare,*
> *A globe, yea world by that impression grow,*
> *Till thy tears mixt with mine doe overflow*
> *This world, by waters sent from thee, my heaven dissolved so.*[3]

Here we find at least two connexions which are not implicit in the first figure, but are forced upon it by the poet: from the geographer's globe to the tear, and the tear to the deluge. On the other hand, some of Donne's most successful and characteristic effects are secured by brief words and sudden contrasts:

> *A bracelet of bright hair about the bone,*[4]

where the most powerful effect is produced by the sudden contrast of associations of "bright hair" and of "bone." This telescoping of images and multiplied associations is characteristic of the phrase of some of the dramatists of the period which Donne knew: not

1 *"To Destiny"* Abraham Cowley's "Destiny" (1656).

2 *"A Valediction"* Donne's poem "A Valediction: Forbidding Mourning" (1633).

3 *On a round ... dissolved so* From Donne's "A Valediction: Of Weeping" (1633) 10–18.

4 *A bracelet ... bone* From "The Relic" (1633) 6.

to mention Shakespeare, it is frequent in Middleton, Webster, and Tourneur, and is one of the sources of the vitality of their language.

Johnson, who employed the term "metaphysical poets," apparently having Donne, Cleveland, and Cowley chiefly in mind, remarks of them that "the most heterogeneous ideas are yoked by violence together."[1] The force of this impeachment lies in the failure of the conjunction, the fact that often the ideas are yoked but not united; and if we are to judge of styles of poetry by their abuse, enough examples may be found in Cleveland to justify Johnson's condemnation. But a degree of heterogeneity of material compelled into unity by the operation of the poet's mind is omnipresent in poetry. We need not select for illustration such a line as

> Notre ame est un trois-mats cherchant son Icarie;[2]

we may find it in some of the best lines of Johnson himself (*The Vanity of Human Wishes*):

> His fate was destined to a barren strand,
> A petty fortress, and a dubious hand;
> He left a name at which the world grew pale,
> To point a moral, or adorn a tale—

where the effect is due to a contrast of ideas, different in degree but the same in principle, as that which Johnson mildly reprehended. And in one of the finest poems of the age (a poem which could not have been written in any other age), the *Exequy* of Bishop King, the extended comparison is used with perfect success: the idea and the simile become one, in the passage in which the Bishop illustrates his impatience to see his dead wife, under the figure of a journey:

1 *"the most ... together"* Samuel Johnson in his "Life of Cowley" (1779).
2 *Notre ... Icarie* French: "Our soul is a three-masted ship seeking its Icaria." From Charles Baudelaire's "Le Voyage" (1859).

> *Stay for me there; I will not faile*
> *To meet thee in that hollow Vale.*
> *And think not much of my delay;*
> *I am already on the way,*
> *And follow thee with all the speed*
> *Desire can make, or sorrows breed.*
> *Each minute is a short degree,*
> *And ev'ry houre a step towards thee.*
> *At night when I betake to rest,*
> *Next morn I rise nearer my West*
> *Of life, almost by eight houres sail,*
> *Than when sleep breath'd his drowsy gale....*
> *But heark! My Pulse, like a soft Drum*
> *Beats my approach, tells Thee I come;*
> *And slow howere my marches be,*
> *I shall at last sit down by Thee.*

(In the last few lines there is that effect of terror which is several times attained by one of Bishop King's admirers, Edgar Poe.) Again, we may justly take these quatrains from Lord Herbert's "Ode,"[1] stanzas which would, we think, be immediately pronounced to be of the metaphysical school:

> *So when from hence we shall be gone,*
> *And be no more, nor you, nor I,*
> *As one another's mystery,*
> *Each shall be both, yet both but one.*
>
> *This said, in her up-lifted face,*
> *Her eyes, which did that beauty crown,*
> *Were like two starrs, that having faln down,*
> *Look up again to find their place:*
>
> *While such a moveless silent peace*
> *Did seize on their becalmed sense,*
> *One would have thought some influence*
> *Their ravished spirits did possess.*

1 *Lord Herbert's "Ode"* Edward Herbert, Lord Cherbury's "An Ode Upon a Question Moved, Whether Love Should Continue Forever?" (1664).

There is nothing in these lines (with the possible exception of the stars, a simile not at once grasped, but lovely and justified) which fits Johnson's general observations on the metaphysical poets in his essay on Cowley. A good deal resides in the richness of association which is at the same time borrowed from and given to the word "becalmed"; but the meaning is clear, the language simple and elegant. It is to be observed that the language of these poets is as a rule simple and pure; in the verse of George Herbert this simplicity is carried as far as it can go—a simplicity emulated without success by numerous modern poets. The *structure* of the sentences, on the other hand, is sometimes far from simple, but this is not a vice; it is a fidelity to thought and feeling. The effect, at its best, is far less artificial than that of an ode by Gray. And as this fidelity induces variety of thought and feeling, so it induces variety of music. We doubt whether, in the eighteenth century, could be found two poems in nominally the same metre, so dissimilar as Marvell's "Coy Mistress" and Crashaw's "Saint Teresa"; the one producing an effect of great speed by the use of short syllables, and the other an ecclesiastical solemnity by the use of long ones:

> *Love, thou art absolute sole lord*
> *Of life and death.*

If so shrewd and sensitive (though so limited) a critic as Johnson failed to define metaphysical poetry by its faults, it is worthwhile to inquire whether we may not have more success by adopting the opposite method: by assuming that the poets of the seventeenth century (up to the Revolution)[1] were the direct and normal development of the precedent age; and, without prejudicing their case by the adjective "metaphysical," consider whether their virtue was not something permanently valuable, which subsequently disappeared, but ought not to have disappeared. Johnson has hit, perhaps by accident, on one of their peculiarities, when he observes that "their attempts were always analytic"; he would not agree that, after the dissociation, they put the material together again in a new unity.

1 *Revolution* I.e., the English Revolution, 1640–60.

It is certain that the dramatic verse of the later Elizabethan and early Jacobean poets expresses a degree of development of sensibility which is not found in any of the prose, good as it often is. If we except Marlowe, a man of prodigious intelligence, these dramatists were directly or indirectly (it is at least a tenable theory) affected by Montaigne. Even if we except also Jonson and Chapman, these two were notably erudite, and were notably men who incorporated their erudition into their sensibility: their mode of feeling was directly and freshly altered by their reading and thought. In Chapman especially there is a direct sensuous apprehension of thought, or a re-creation of thought into feeling, which is exactly what we find in Donne:

> *in this one thing, all the discipline*
> *Of manners and of manhood is contained;*
> *A man to join himself with th' Universe*
> *In his main sway, and make in all things fit*
> *One with that All, and go on, round as it;*
> *Not plucking from the whole his wretched part,*
> *And into straits, or into nought revert,*
> *Wishing the complete Universe might be*
> *Subject to such a rag of it as he;*
> *But to consider great Necessity.*[1]

We compare this with some modern passage:

> *No, when the fight begins within himself,*
> *A man's worth something. God stoops o'er his head*
> *Satan looks up between his feet—both tug—*
> *He's left, himself, i' the middle; the soul wakes*
> *And grows. Prolong that battle through his life!*[2]

It is perhaps somewhat less fair, though very tempting (as both poets are concerned with the perpetuation of love by offspring), to compare with the stanzas already quoted from Lord Herbert's "Ode" the following from Tennyson:

1 *in this one ... Necessity* From *The Revenge of Bussy d'Ambois* (1613), 4.1.
2 *No ... life* From Robert Browning's "Bishop Blougram's Apology" (1855), 693–97.

One walked between his wife and child,
With measured footfall firm and mild,
And now and then he gravely smiled.

The prudent partner of his blood
Leaned on him, faithful, gentle,
Wearing the rose of womanhood.

And in their double love secure,
The little maiden walked demure,
Pacing with downward eyelids pure.

These three made unity so sweet,
My frozen heart began to beat,
Remembering its ancient heat.[1]

The difference is not a simple difference of degree between poets. It is something which had happened to the mind of England between the time of Donne or Lord Herbert of Cherbury and the time of Tennyson and Browning; it is the difference between the intellectual poet and the reflective poet. Tennyson and Browning are poets, and they think; but they do not feel their thought as immediately as the odour of a rose. A thought to Donne was an experience; it modified his sensibility. When a poet's mind is perfectly equipped for its work, it is constantly amalgamating disparate experience; the ordinary man's experience is chaotic, irregular, fragmentary. The latter falls in love, or reads Spinoza, and these two experiences have nothing to do with each other, or with the noise of the typewriter or the smell of cooking; in the mind of the poet these experiences are always forming new wholes.

We may express the difference by the following theory: The poets of the seventeenth century, the successors of the dramatists of the sixteenth, possessed a mechanism of sensibility which could devour any kind of experience. They are simple, artificial, difficult, or fantastic, as their predecessors were; no less nor more than Dante, Guido Cavalcanti, Guinicelli, or Cino. In the seventeenth century a dissociation of sensibility set in, from which we have

1 *One walked ... heat* From "The Two Voices" (1833), 412–33.

never recovered; and this dissociation, as is natural, was aggravated by the influence of the two most powerful poets of the century, Milton and Dryden. Each of these men performed certain poetic functions so magnificently well that the magnitude of the effect concealed the absence of others. The language went on and in some respects improved; the best verse of Collins, Gray, Johnson, and even Goldsmith satisfies some of our fastidious demands better than that of Donne or Marvell or King. But while the language became more refined, the feeling became more crude. The feeling, the sensibility, expressed in the "Country Churchyard"[1] (to say nothing of Tennyson and Browning) is cruder than that in the "Coy Mistress."[2]

The second effect of the influence of Milton and Dryden followed from the first, and was therefore slow in manifestation. The sentimental age began early in the eighteenth century, and continued. The poets revolted against the ratiocinative, the descriptive; they thought and felt by fits, unbalanced; they reflected. In one or two passages of Shelley's "Triumph of Life," in the second *Hyperion*,[3] there are traces of a struggle toward unification of sensibility. But Keats and Shelley died, and Tennyson and Browning ruminated.

After this brief exposition of a theory—too brief, perhaps, to carry conviction—we may ask, what would have been the fate of the "metaphysical" had the current of poetry descended in a direct line from them, as it descended in a direct line to them? They would not, certainly, be classified as metaphysical. The possible interests of a poet are unlimited; the more intelligent he is the better; the more intelligent he is the more likely that he will have interests: our only condition is that he turn them into poetry, and not merely meditate on them poetically. A philosophical theory which has entered into poetry is established, for its truth or falsity in one sense ceases to matter, and its truth in another sense is proved. The poets in question have, like other poets, various faults. But they were, at best, engaged in the task

1 *"Country Churchyard"* Thomas Gray's "Elegy Written in a Country Church-Yard" (1751).

2 *"Coy Mistress"* Andrew Marvell's "To His Coy Mistress" (1681).

3 *Hyperion* John Keats began his epic fragment in 1818; in 1819 he revised the poem and wrote *The Fall of Hyperion, A Dream.*

of trying to find the verbal equivalent for states of mind and feeling. And this means both that they are more mature, and that they wear better, than later poets of certainly not less literary ability.

It is not a permanent necessity that poets should be interested in philosophy, or in any other subject. We can only say that it appears likely that poets in our civilization, as it exists at present, must be *difficult*. Our civilization comprehends great variety and complexity, and this variety and complexity, playing upon a refined sensibility, must produce various and complex results. The poet must become more and more comprehensive, more allusive, more indirect, in order to force, to dislocate if necessary, language into his meaning. (A brilliant and extreme statement of this view, with which it is not requisite to associate oneself, is that of M. Jean Epstein,[1] *La Poésie d'aujourd'hui*.) Hence we get something which looks very much like the conceit—we get, in fact, a method curiously similar to that of the "metaphysical poets," similar also in its use of obscure words and of simple phrasing.

> *O géraniums diaphanes, guerroyeurs sortilèges,*
> *Sacrilèges monomanes!*
> *Emballages, dévergondages, douches! O pressoirs*
> *Des vendanges des grands soirs!*
> *Layettes aux abois,*
> *Thyrses au fond des bois!*
> *Transfusions, représailles,*
> *Relevailles, compresses et l'éternel potion,*
> *Angélus! n'en pouvoir plus*
> *De débâcles nuptiales! de débâcles nuptiales!*[2]

The same poet could write also simply:

1 *M. Jean Epstein* French intellectual (1897–1953).
2 *O géraniums ... nuptiales* French: "O diaphanous geraniums, warrior magic spells, / Monomaniacal sacrileges! / Packing materials, licentiousness, showers! O presses / Of the great evening grape harvests! / Pressed baby clothes, / Thyrsis deep in the woods! / Transfusions, reprisals, / Reawakenings, compresses, and the eternal potion, / Angelus! No longer able / Marriage debacles! Marriage debacles!" From Jules Laforgue's *Derniers vers* (1890).

Elle est bien loin, elle pleure,
Le grand vent se lamente aussi ...[1]

Jules Laforgue, and Tristan Corbière in many of his poems, are nearer to the "school of Donne" than any modern English poet. But poets more classical than they have the same essential quality of transmuting ideas into sensations, of transforming an observation into a state of mind.

Pour l'enfant, amoureux de cartes et d'estampes,
L'univers est égal à son vaste appétit.
Ah, que le monde est grand à la clarté des lampes!
Aux yeux du souvenir que le monde est petit![2]

In French literature the great master of the seventeenth century—Racine—and the great master of the nineteenth—Baudelaire—are in some ways more like each other than they are like anyone else. The greatest two masters of diction are also the greatest two psychologists, the most curious explorers of the soul. It is interesting to speculate whether it is not a misfortune that two of the greatest masters of diction in our language, Milton and Dryden, triumph with a dazzling disregard of the soul. If we continued to produce Miltons and Drydens it might not so much matter, but as things are it is a pity that English poetry has remained so incomplete. Those who object to the "artificiality" of Milton or Dryden sometimes tell us to "look into our hearts and write." But that is not looking deep enough; Racine or Donne looked into a good deal more than the heart. One must look into the cerebral cortex, the nervous system, and the digestive tracts.

May we not conclude, then, that Donne, Crashaw, Vaughan, Herbert and Lord Herbert, Marvell, King, Cowley at his best, are in the direct current of English poetry, and that their faults should be reprimanded by this standard rather than coddled by antiquarian affection? They have been enough praised in terms

1 *Elle est bien ... aussi* French: "She is far away, she cries, / The high wind also laments." From *Derniers vers*.
2 *Pour l'enfant ... est petit* French: "For the child, loving maps and stamps, / The universe is his vast appetite. / Ah, how large the world is by the clear light of the lamps! / To eyes remembering that the world is small." From Baudelaire's *Le Voyage*.

which are implicit limitations because they are "metaphysical" or "witty," "quaint" or "obscure," though at their best they have not these attributes more than other serious poets. On the other hand, we must not reject the criticism of Johnson (a dangerous person to disagree with) without having mastered it, without having assimilated the Johnsonian canons of taste. In reading the celebrated passage in his essay on Cowley we must remember that by wit he clearly means something more serious than we usually mean today; in his criticism of their versification we must remember in what a narrow discipline he was trained, but also how well trained; we must remember that Johnson tortures chiefly the chief offenders, Cowley and Cleveland. It would be a fruitful work, and one requiring a substantial book, to break up the classification of Johnson and exhibit these poets in all their difference of kind and of degree, from the massive music of Donne to the faint, pleasing tinkle of Aurelian Townshend.

—1921

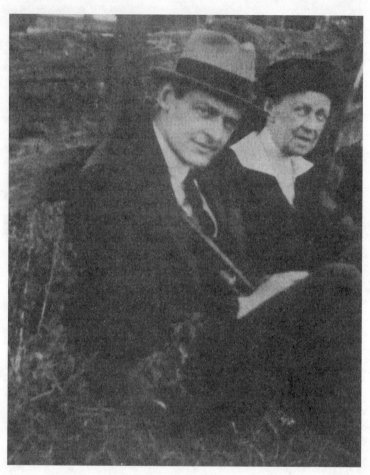

Eliot with his mother in England, 1921.

In Context

Eliot and Modernism

According to Virginia Woolf's oft-quoted formulation (from a 1924 essay excerpted in this book), "on or about December 1910 human character changed." Woolf saw that date as marking the moment at which writers began smashing literary conventions in an effort to represent the complexity of human experience through "the spasmodic, the obscure, the fragmentary." At the same moment, painting and sculpture were breaking visual reality into fragments to express the reality of fragmented experience—or indeed to express the reality of what increasingly seemed a fragmented world. Such is now a conventional account of the birth of Modernism.

There was, of course, a mock-precision in Woolf's dating, but many others have linked the birth of Modernism to developments that occurred at *about* this time: in poetry, the development of Imagism and its offshoots by Ezra Pound, H.D., and, a few years later, T.S. Eliot; in fiction, the development by Dorothy Richardson, James Joyce, Virginia Woolf, and others, of "stream of consciousness" techniques of narration; in painting, the development of Cubism by Pablo Picasso and Georges Braque; in music, the development of strikingly discordant styles such as that of Igor Stravinsky's *The Rite of Spring*; and the development of Futurism by F.T. Marinetti and others. Arguably, though, the birth of Modernism can be traced to developments that occurred in France considerably earlier—developments such as Arthur Rimbaud's wholesale rejection in 1871 of the conventions of Western poetry. In the 1880s and 90s the Symbolist aesthetic of poets Jules Laforgue and Stephane Mallarmé foreshadowed the coming of Modernism even more directly than had that of Rimbaud. In the 1891 interview excerpted below, Mallarmé asserted that "when a society is without stability, without unity, it cannot create a stable and definitive art," and suggested that we must not try to elude the intellectual work that is entailed in coming to terms with the appropriate obscurity of poetry. A generation later, T.S. Eliot declared (in his essay "The Metaphysical Poets,"

included in this book) that "poets in our civilization ... must be *difficult*. Our civilization comprehends great variety and complexity, and this variety and complexity ... must produce various and complex results. The poet must become ... more allusive, more indirect, in order to force, to dislocate if necessary, language into his meaning."

The vortex of Modernism includes within it a wide variety of narrower "isms"—including not only Post-Impressionism, Symbolism, Imagism, and Futurism, but also Vorticism, Absurdism, Dadaism, and a number of others. All shun the linear, the decorative, and the sentimental. All tend towards the presentation of reality fractured into its component pieces—and towards a rejection of all traditions within which reality is represented through the construction of conventionally unified wholes. Often, however, it was suggested that the fractured forms might represent the world as humans *perceive* it more realistically than other, seemingly more "realistic" forms of representation. Such was the case with stream of consciousness narration in fiction, for example, and also with Cubism; Picasso is famously reported to have said of his Cubist work, "I paint objects as I think them, not as I see them."

In the revolutionary ferment of the late eighteenth and early nineteenth centuries, there was a close correlation between literary or artistic positions and political ones; those who held radical political views tended also to hold radical aesthetic ones. In the revolutionary ferment of Modernism a century later, however, the lines of association between the aesthetic and the political are much more tangled; certainly it would be difficult to argue that Modernism was particularly friendly towards the political left. While Woolf and most of the Bloomsbury circle held progressive political views, Pound and many of the Futurists gravitated towards fascism, Eliot towards conservative High Anglicanism. Modernism's strong desire to recognize the force of often anarchic psychological impulse eventually found its most venomous expression in the racism and anti-Semitism of Pound ("Let us be done with Jews ... / Let us spit on those who fawn on the Jews for their money"). Nor was Modernism on the whole friendly towards feminism—or, more generally, towards women. H.D., Richardson, and Woolf must be numbered among the major figures of Modernism—and in the long run, their writing on issues relating to gender has counted more than the less progressive pronouncements

of some other Modernist figures. But in their own time, the virulent misogyny of such figures as Marinetti and Pound (and the much milder variety of Eliot) had a wide-ranging impact, on literature as in other contexts. The "modern woman" that had been so central to the cultural world at the turn of the century was of little interest to the figures of Modernism. (Paradoxically, though, the climate that Modernism helped to create may not, finally, have been hostile to women or to progressive causes, if only because Modernism promoted the belief that nothing is stable—and thus implicitly that change can occur in surprising directions, and with surprising speed.)

from Jules Huret, "Interview with Stephane Mallarmé," *L'Echo de Paris* (1891)

... "We are taking part, at this moment," he told me, "in an extraordinary spectacle, unique in all the history of poetry.... Until now, poets had to have as accompaniment the grand organ notes of regular meter. Well, they have been played too much, and one gets tired of it.... When he was dying I'm sure the great [Victor] Hugo convinced himself that he had buried poetry for a century—yet even then, Paul Verlaine had already written 'Sagesse'; Hugo failed above all to realise that in a society without stability, without unity, it is not possible to create an art that is stable, that is definitive...."

"So much for the form," I said to Mr. Mallarmé. "And the content?"

"I believe," he answered me, "that the young are closer to the poetic ideal than the old Parnassians,[1] who ... try to present their subjects plainly and directly. I believe that it is necessary to have nothing but allusion. The contemplation of objects, images flying dreamlike from the eyes—these are the song. The Parnassians take the thing as a whole and look at it, but they rob it of its mystery.... To name a thing is to take away three quarters of the enjoyment of a poem, which is to be found in divining little by little...."

"We come now," I said to him, "to a great objection that I am obliged to raise with you—the issue of *obscurity*."

1 *Parnassians* School of French poetry whose members (which included Paul Verlaine, Catulle Mendes, and Pierre Louÿs) reacted against Romanticism, preferring instead the formal structure and emotional detachment of classicist poetry.

"This is equally dangerous," he replied to me, "if the obscurity comes from the insufficiencies of the reader, or those of the poet—but it is deceitful to try to get away from this work [of unravelling the poem].... There ought always to be an enigma in poetry, and it is the purpose of literature—there is no other—to *evoke* objects."

... "Is it you, sir," I now demanded of him, "who has created the new movement?"

"I abhor schools," he said, "and all that they represent: ... literature, to the contrary, is entirely an individual matter. For me, the case of the poet in this society that does not allow one to live, resembles the situation of a man confined in isolation...."

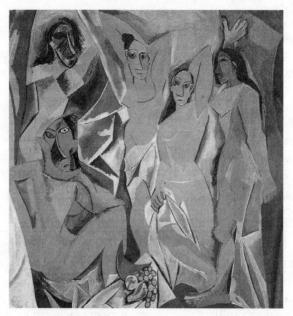

Pablo Picasso, *Les Demoiselles d'Avignon* (1907)

The style of painting known as Cubism was developed by the Spanish painter Pablo Picasso and French painter Georges Braque in 1907. Braque had been much influenced by the landscapes of the French impressionist Paul Cézanne, in which land, sea, and sky are loosely broken up into soft blocks of color; by 1907 he was developing a style that fragmented landscape much more radically than had Cézanne. Meanwhile Picasso, influenced by traditions of African portraiture through mask, was developing

a similarly radical approach to the depiction of the human body. When Braque visited Picasso's studio in the spring of 1907, Picasso showed his groundbreaking painting *Les Demoiselles d'Avignon*, which depicts five women from a brothel in dramatically fragmented fashion. For the next few years, Braque and Picasso followed similar lines of development in their painting.

Though *Les Demoiselles d'Avignon* is now regarded as a landmark in the development of Cubism—and of Modernism generally—it was not well received initially. The leading Post-Impressionist painter Henri Matisse thought the painting represented an attack on "the modern movement," while Picasso's friend and patron Leo Stein is reported to have said sarcastically, "You have been trying to paint the fourth dimension; how amusing!" Picasso did not publicly exhibit the painting until 1925.

Imagist and Futurist Poetry: A Sampling

T.E. Hulme (1883-1917)

Art and literary critic, philosopher, and friend of T.S. Eliot, T.E. Hulme wrote some of the earliest "Modernist" poetry in English. He enlisted in the artillery when the First World War broke out, and was killed in battle in 1917.

"Autumn" (1912)

A touch of gold in the Autumn night—
Walked abroad,
And saw the ruddy moon lean over a hedge
Like a red-faced farmer.
I did not stop to speak, but nodded,
And round about were the wistful stars
With white faces like town children.

Ezra Pound (1885-1972)

Ezra Pound was an expatriate American in London when he became a leading force behind the poetic movement known as "Imagism" and subsequently behind the intellectual and artistic movement known as "Vorticism." After leaving Britain, he spent years in Italy, where, notoriously, he broadcast propaganda for Mussolini's Fascist government during World War II, actions for which he narrowly avoided charges of treason upon his return to the United States.

While he is himself reckoned among the most important of Modernist poets, he also played a central role in the development of Modernist poetry as a whole through his friendships with talented contemporaries such as William Carlos Williams and H.D. In particular, he exerted a prolonged influence on the poetry of T.S. Eliot, most notably through his significant editorial work on *The Waste Land*. The critic Hugh Kenner, who wrote extensively on Pound and his work, said that when he met the poet "I knew that I was in the presence of the center of Modernism."

Ezra Pound, 1920

"In a Station of the Metro" (1916, written c. 1911)

> The apparition of these faces in the crowd;
> Petals on a wet, black bough.

"Alba" (1916)

> As cool as the pale wet leaves
> of lily-of-the-valley
> She lay beside me in the dawn.

"L'Art, 1910" (1916)

> Green arsenic smeared on an egg-white cloth,
> Crushed strawberries! Come, let us feast our eyes.

H.D. (1886-1961)

Like T.S. Eliot and Ezra Pound (to whom she was twice engaged), H.D. was an American expatriate whose work was central to Modernism. Born and educated in Pennsylvania as Hilda Doolittle, she left for Europe in 1911, and soon became known as an Imagist poet. She lived thereafter in England and later in Switzerland, identifying herself as "H.D." beginning in 1913. A writer of fiction as well as of poetry, in 1927 she wrote the pioneering novel *HERmione*, exploring the tension between a woman's lesbian and heterosexual feelings. Her long poem *Trilogy* (1944-46) is regarded by many as her most important work.

"Oread" (1914)

> Whirl up, sea—
> whirl your pointed pines,
> splash your great pines
> on our rocks,
> hurl your green over us,
> cover us with your pools of fir.

"The Pool" (1915)

Are you alive?
I touch you.
You quiver like a sea-fish.
I cover you with my net.
What are you—banded one?

Mina Loy (1882-1966)

Loy is often categorized as a Futurist poet, though she had a stormy relationship with many of the Futurists. She is also often discussed as an American poet, although she was 34 and had already composed most of the work for which she is now best remembered when she left Europe for America. She moved to the United States in 1916 and soon became a part of the New York avant-garde. Born and raised in England, Loy had by then also spent several years amidst the literary and artistic community in Paris, devoting considerable time to painting before turning to poetry in the 1910s. When her "Love Songs" was published in the debut issue of a New York magazine called *Others* in 1915, both the poem and its author immediately became notorious. In 1921, Ezra Pound (then living outside America) suggested that Loy, Marianne Moore, and William Carlos Williams were the only three writers then in the United States "who can write anything of interest in verse."

Recently, Loy has again become notorious, this time for the *Feminist Manifesto* that she wrote in 1914, which includes such incendiary lines as "Men and women are enemies, with the enmity of the exploited for the parasite, the parasite for the exploited ... The only point at which the interests of the sexes merge—is the sexual embrace." Loy drafted the manifesto as an angry response to the misogynist manifestos of the Italian Futurists and (earlier that same year) the BLAST manifesto of Pound, Wyndham Lewis, and others; Loy considered it merely a rough draft, however, and chose not to publish it; the manifesto did not appear in print until 1982.

There are numerous versions of many of Loy's poems; notably, a longer and more explicitly erotic version of "Love Songs" appeared under the title "Love Songs to Joannes."

from "Three Moments in Paris" (1915, written 1914)

1. ONE O'CLOCK AT NIGHT

Though you have never possessed me
I have belonged to you since the beginning of time
And sleepily I sit on your chair beside you
Leaning against your shoulder
And your careless arm across my back gesticulates
As your indisputable male voice roars
Through my brain and my body
Arguing "Dynamic Decomposition"
Of which I understand nothing
Sleepily
And the only less male voice of your brother
 pugilist of the intellect
Booms as it seems to me so sleepy
Across an interval of a thousand miles
An interim of a thousand years
But you who make more noise than any man
 in the world when you clear your throat
Deafening wake me
And I catch the thread of the argument
Immediately assuming my personal mental attitude
And cease to be a woman

Beautiful halfhour of being a mere woman
The animal woman
Understanding nothing of man
But mastery and the security of imparted
 physical heat
Indifferent to cerebral gymnastics
Or regarding them as the self-indulgent play of children
Or the thunder of alien gods
But you wake me up
Anyhow who am I that I should criticize
 your theories of "Plastic Velocity"

"Let us go home she is tired and wants to go to bed."

from "Love Songs" (1915)

I

Spawn of Fantasies
Sitting[1] the appraisable
Pig Cupid[2] his rosy snout
Rooting erotic garbage
"Once upon a time"
Pulls a weed white star-topped
Among wild oats sown in mucous-membrane
I would an eye in a Bengal light
Eternity in a sky-rocket
Constellations in an ocean
Whose rivers run no fresher
Than a trickle of saliver[3]

There are suspect places
I must live in my lantern
Trimming subliminal flicker
Virginal to the bellows
Of experience

 Coloured glass

1 *Sitting* The handwritten original may read "silting."
2 *Pig Cupid* The poem as a whole is often referred to as "Pig Cupid."
3 *saliver* In most published versions this spelling is corrected to "saliva," but the handwritten original reads "-er," and it seems plausible that a connection with the "-er" ending of "fresher" is intended.

Imagism and Vorticism

In his earliest work, Eliot identified with Imagism, and the movement influenced his poetry as a whole. Richard Aldington, H.D.'s husband, wrote in his memoirs that "to a considerable extent T.S. Eliot and his followers have carried on their operations from positions won by the Imagists."

The first two of the following selections appeared together in a 1913 issue of *Poetry* magazine: a short article by civil servant, poet, and translator F.S. Flint on Imagism was followed by a longer discussion of Imagism by Ezra Pound. In an article on Vorticism three years later Pound made further efforts to define Imagism and Vorticism—as well as to define and comment on Impressionism and Post-Impressionism, Symbolism, and various other of the component movements of Modernism.

from F.S. Flint, "Imagisme,"[1] *Poetry Magazine* (March 1913)

Some curiosity has been aroused concerning *Imagisme*, and as I was unable to find anything definite about it in print, I sought out an *Imagiste*, with intent to discover whether the group itself knew anything about the "movement." I gleaned these facts.

The *Imagistes* admitted that they were contemporaries of the Post Impressionists and the Futurists; but they had nothing in common with these schools. They had not published a manifesto.... They had a few rules, drawn up for their own satisfaction only, and they had not published them. They were:

1. Direct treatment of the "thing," whether subjective or objective.
2. To use absolutely no word that does not contribute to the presentation.
3. As regarding rhythm: to compose in sequence of the musical phrase, not in sequence of the metronome. By these standards they judged all poetry and found most of it wanting....

1 [1913 note from the editors of *Poetry* magazine.] In response to many requests for information regarding Imagism and the Imagistes, we publish this note by Mr. Flint, supplementing it with further exemplification by Mr. Pound. It will be seen from these that Imagism is not necessarily associated with Hellenic subjects, or with *vers libre* as a prescribed form.

I found among them an earnestness that is amazing to one accustomed to the usual London air of poetic dilettantism. They consider that Art is all science, all religion, philosophy and metaphysic. It is true that *snobisme* may be urged against them; but it is at least *snobisme* in its most dynamic form, with a great deal of sound sense and energy behind it; and they are stricter with themselves than with any outsider.

from Ezra Pound, "A Few Don'ts by an Imagiste," *Poetry* (March 1913)

An "Image" is that which presents an intellectual and emotional complex in an instant of time. I use the term "complex" rather in the technical sense employed by the newer psychologists, such as Hart, though we might not agree absolutely in our application.

It is the presentation of such a "complex" instantaneously which gives that sense of sudden liberation; that sense of freedom from time limits and space limits; that sense of sudden growth, which we experience in the presence of the greatest works of art.

It is better to present one Image in a lifetime than to produce voluminous works....

LANGUAGE

Use no superfluous word, no adjective, which does not reveal something.

Don't use such an expression as "dim lands *of peace*." It dulls the image. It mixes an abstraction with the concrete. It comes from the writer's not realizing that the natural object is always the *adequate* symbol.

Go in fear of abstractions. Don't retell in mediocre verse what has already been done in good prose. Don't think any intelligent person is going to be deceived when you try to shirk all the difficulties of the unspeakably difficult art of good prose by chopping your composition into line lengths.

What the expert is tired of today the public will be tired of tomorrow.

Don't imagine that the art of poetry is any simpler than the art of music, or that you can please the expert before you have spent at least as much effort on the art of verse as the average piano teacher spends on the art of music....

Rhythm and Rhyme

Let the candidate fill his mind with the finest cadences he can discover, preferably in a foreign language so that the meaning of the words may be less likely to divert his attention from the movement; e.g., Saxon charms, Hebridean Folk Songs, the verse of Dante, and the lyrics of Shakespeare—if he can dissociate the vocabulary from the cadence. Let him dissect the lyrics of Goethe coldly into their component sound values, syllables long and short, stressed and unstressed, into vowels and consonants.

It is not necessary that a poem should rely on its music, but if it does rely on its music that music must be such as will delight the expert.

Let the neophyte know assonance and alliteration, rhyme immediate and delayed, simple and polyphonic, as a musician would expect to know harmony and counter-point and all the minutiae of his craft. No time is too great to give to these matters or to any one of them, even if the artists seldom have need of them....

Don't chop your stuff into separate *iambs*. Don't make each line stop dead at the end, and then begin every next line with a heave. Let the beginning of the next line catch the rise of the rhythm wave, unless you want a definite longish pause.

In short, behave as a musician, a good musician, when dealing with that phase of your art which has exact parallels in music. The same laws govern, and you are bound by no others.

Naturally, your rhythmic structure should not destroy the shape of your words, or their natural sound, or their meaning. It is improbable that, at the start, you will be able to get a rhythm-structure strong enough to affect them very much, though you may fall a victim to all sorts of false stopping due to line ends and caesurae.

The musician can rely on pitch and the volume of the orchestra. You can not. The term harmony is misapplied to poetry; it refers to simultaneous sounds of different pitch. There is, however, in the best verse a sort of residue of sound which remains in the ear of the hearer and acts more or less as an organ-base. A rhyme must have in it some slight element of surprise if it is to give pleasure; it need not be bizarre or curious, but it must be well used if used at all....

The first three simple proscriptions will throw out nine-tenths of all the bad poetry now accepted as standard and classic; and will prevent you from many a crime of production....

from Ezra Pound, "Vorticism," *Gaudier-Brzeska* (1916)

"It is no more ridiculous that a person should receive or convey an emotion by means of an arrangement of shapes, or planes, or colours, than that they should receive or convey such emotion by an arrangement of musical notes."

I suppose this proposition is self-evident. Whistler[1] said as much, some years ago, and Pater[2] proclaimed that "All arts approach the condition of music."

· Whenever I say this I am greeted with a storm of "Yes, but"s. "But why isn't this art futurism?" "Why isn't?" "Why don't?" and above all: "What, in Heaven's name, has it got to do with your Imagiste poetry?"

Let me explain at leisure, and in nice, orderly, old-fashioned prose....

"Futurism," when it gets into art, is, for the most part, a descendant of impressionism. It is a sort of accelerated impressionism.

There is another artistic descent *via* Picasso and Kandinsky;[3] *via* cubism and expressionism. One does not complain of neo-impressionism or of accelerated impressionism and "simultaneity," but one is not wholly satisfied by them. One has perhaps other needs.

... Vorticism has been announced as including such and such painting and sculpture and "Imagisme" in verse. I shall explain "Imagisme," and then proceed to show its inner relation to certain modern paintings and sculpture.

Imagisme, in so far as it has been known at all, has been known chiefly as a stylistic movement, as a movement of criticism rather than of creation. This is natural, for, despite all possible celerity of publication, the public is always, and of necessity, some years behind the artists' actual thought....

Imagisme is not symbolism. The symbolists dealt in "association," that is, in a sort of allusion, almost of allegory. They degraded the symbol to the status of a word. They made it a form of metonymy. One can be grossly "symbolic," for example, by using the term "cross" to mean "trial." The symbolist's *symbols* have a fixed value, like num-

1 *Whistler* American painter James Abbott McNeill Whistler (1834-1903).
2 *Pater* English critic Walter Pater (1839-94).
3 *Kandinsky* Russian abstract painter Wassily Kandinsky (1866-1944).

bers in arithmetic, like 1, 2, and 7. The imagiste's images have a variable significance, like the signs *a, b,* and *x* in algebra.

Moreover, one does not want to be called a symbolist, because symbolism has usually been associated with mushy technique.

On the other hand, Imagisme is not Impressionism, though one borrows, or could borrow, much from the impressionist method of presentation. But this is only negative definition....

The Image is the poet's pigment.[1] The painter should use his colour because he sees it or feels it. I don't much care whether he is representative or non-representative. He should *depend,* of course, on the creative, not upon the mimetic or representational part in his work. It is the same in writing poems, the author must use his *image* because he sees it or feels it, *not* because he thinks he can use it to back up some creed or some system of ethics or economics.

An *image*, in our sense, is real because we know it directly....

Any mind that is worth calling a mind must have needs beyond the existing categories of language, just as a painter must have pigments or shades more numerous than the existing names of the colours.

Perhaps this is enough to explain the words in my "Vortex":—

"Every concept, every emotion, presents itself to the vivid consciousness in some primary form. It belongs to the art of this form...."

What I have said of one Vorticist art can be transposed for another vorticist art. But let me go on then with my own branch of vorticism, about which I can probably speak with greater clarity. All poetic language is the language of exploration. Since the beginning of bad writing, writers have used images as ornaments. The point of Imagisme is that it does not use images *as ornaments*. The image is itself the speech. The image is the word beyond formulated language.

I once saw a small child go to an electric light switch and say, "Mamma, can I *open* the light?" She was using the age-old language of exploration, the language of art. It was a sort of metaphor, but she was not using it as ornamentation.

One is tired of ornamentations, they are all a trick, and any sharp person can learn them.

The Japanese have had the sense of exploration. They have understood the beauty of this sort of knowing. A Chinaman said long ago

1 [Pound's note] The image has been defined as "that which presents an intellectual and emotional complex in an instant of time."

that if a man can't say what he has to say in twelve lines he had better keep quiet. The Japanese have evolved the still shorter form of the *hokku*.[1]

The fallen blossom flies back to its branch:
A butterfly.

That is the substance of a very well-known *hokku*. Victor Plarr[2] tells me that once, when he was walking over snow with a Japanese naval officer, they came to a place where a cat had crossed the path, and the officer said, "Stop, I am making a poem." Which poem was, roughly, as follows:—

The footsteps of the cat upon the snow:
(are like) plum-blossoms.

The words "are like" would not occur in the original, but I add them for clarity. The "one image poem" is a form of super-position, that is to say, it is one idea set on top of another. I found it useful in getting out of the impasse in which I had been left by my metro emotion. I wrote a thirty-line poem, and destroyed it because it was what we call work "of second intensity." Six months later I made a poem half that length; a year later I made the following *hokku*-like sentence:—

The apparition of these faces in the crowd:
Petals, on a wet, black bough.

I dare say it is meaningless unless one has drifted into a certain vein of thought.[3] In a poem of this sort one is trying to record the precise instant when a thing outward and objective transforms itself, or darts into a thing inward and subjective.

1 *hokku* I.e., haiku.
2 *Victor Plarr* English poet (1863-1929).
3 [Pound's note] Mr. Flint and Mr. Rodker have made longer poems depending on a similar presentation of matter. So also have Richard Aldington, in his *In Via Sestina*, and "H.D." in her *Oread*, which latter poems express much stronger emotions than that in my lines here given. Mr. Hueffer gives an interesting account of a similar adventure of his own in his review of the Imagiste anthology.

I see no reason why I, and various men who agree with me, should be expected to call ourselves futurists. We do not desire to evade comparison with the past. We prefer that the comparison be made by some intelligent person whose idea of "the tradition" is not limited by the conventional taste of four or five centuries and one continent.

Vorticism is an intensive art. I mean by this, that one is concerned with the relative intensity, or relative significance of different sorts of

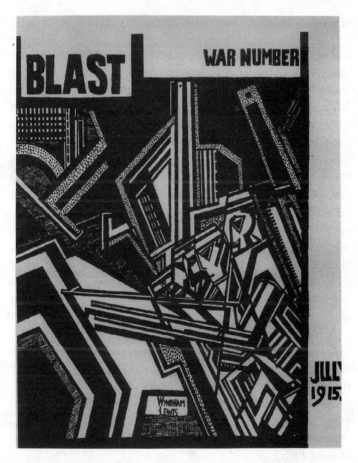

Cover of the second (and last) issue of *BLAST*, July 1915; the cover illustration is a vorticist woodcut by Wyndham Lewis. The first issue (in 1914) included the famous vorticist manifesto signed by Lewis, Pound, and others, and the second included Eliot's poems "Preludes" and "Rhapsody on a Windy Night."

expression. One desires the most intense, for certain forms of expression *are* "more intense" than others. They are more dynamic....

The image is not an idea. It is a radiant node or cluster; it is what I can, and must perforce, call a VORTEX, from which, and through which, and into which, ideas are constantly rushing. In decency one can only call it a VORTEX. And from this necessity came the name "vorticism."

from Virginia Woolf, "Character in Fiction" (1924)

In the essay excerpted below, Virginia Woolf discusses the changes she observes—and, indeed, is helping to create—in the literature of her time. These, she says, are prompted by a change in "human character" that occurred around 1910. Among the significant developments of 1910 in Britain were the death of Edward VII on 6 May, and the groundbreaking exhibition "Manet and the Post-Impressionists," curated by Roger Fry, which opened at the Grafton Galleries on 8 November, and which then unleashed a storm of controversy in the London press. (The term "Post-Impressionist" was invented by Fry before the show as an umbrella term to describe an exhibit that featured work in a variety of disparate styles, including Pointillism, Fauvism, and Symbolism.) As Woolf and Fry were both central figures in the Bloomsbury circle, Woolf may well have had the controversy surrounding this exhibition in mind in choosing 1910 as a reference point—although she does not in fact mention the Post-Impressionists in her essay.

"Character in Fiction" was first published in the *Criterion*, July 1924. Early variants of much of the essay appeared in Woolf's 1923 essay "Mr. Bennett and Mrs. Brown," first published in the "Literary Review" section of the *New York Evening Post*, 17 November 1923, and in a paper read to a group called the Cambridge Heretics on 18 May 1924. (A subsequent version appeared as a pamphlet in 1925, again using the title "Mr. Bennett and Mrs. Brown," published by the Hogarth Press.)

It seems to me possible, perhaps desirable, that I may be the only person in this room who has committed the folly of writing, trying to write, or failing to write, a novel. And when I asked myself, as your invitation to speak to you about modern fiction made me ask myself,

what demon whispered in my ear and urged me to my doom, a little figure rose before me—the figure of a man, or of a woman, who said, "My name is Brown. Catch me if you can."

Most novelists have the same experience. Some Brown, Smith, or Jones comes before them and says in the most seductive and charming way in the world, "Come and catch me if you can." And so, led on by this will-o'-the-wisp, they flounder through volume after volume, spending the best years of their lives in the pursuit, and receiving for the most part very little cash in exchange. Few catch the phantom; most have to be content with a scrap of her dress or a wisp of her hair.

My belief that men and women write novels because they are lured on to create some character which has thus imposed itself upon them has the sanction of Mr. Arnold Bennett.[1] In an article from which I will quote[2] he says: "The foundation of good fiction is character-creating and nothing else ... Style counts; plot counts; originality of outlook counts. But none of these counts anything like so much as the convincingness of the characters. If the characters are real the novel will have a chance; if they are not, oblivion will be its portion..." And he goes on to draw the conclusion that we have no young novelists of first-rate importance at the present moment, because they are unable to create characters that are real, true, and convincing.

These are the questions that I want with greater boldness than discretion to discuss tonight. I want to make out what we mean when we talk about "character" in fiction; to say something about the question of reality which Mr. Bennett raises; and to suggest some reasons why the younger novelists fail to create characters, if, as Mr. Bennett asserts, it is true that fail they do. This will lead me, I am well aware, to make some very sweeping and some very vague assertions. For the question is an extremely difficult one. Think how little we know about character—think how little we know about art. But, to make a clearance before I begin, I will suggest that we range Edwardians and Georgians into two camps; Mr. Wells, Mr. Bennett, and Mr. Galsworthy I will call the Edwardians; Mr. Forster, Mr. Lawrence,

1 *Mr. Arnold Bennett* Bennett (1867-1931) was a leading novelist of the realistic tradition in the early twentieth century. He was the author of over 20 novels, including *The Old Wives' Tale* (1908), *Clayhanger* (1910), and *Riceyman Steps* (1923), as well as non-fiction works such as *Literary Taste and How to Form It* (1909).

2 *article ... quote* Arnold Bennett's article "Is the Novel Decaying?" appeared in *Cassell's Weekly*, 28 March 1923.

Mr. Strachey, Mr. Joyce, and Mr. Eliot I will call the Georgians.[1] And if I speak in the first person, with intolerable egotism, I will ask you to excuse me. I do not want to attribute to the world at large the opinions of one solitary, ill-informed, and misguided individual.

My first assertion is one that I think you will grant—that every one in this room is a judge of character. Indeed it would be impossible to live for a year without disaster unless one practised character-reading and had some skill in the art. Our marriages, our friendships depend on it; our business largely depends on it; every day questions arise which can only be solved by its help. And now I will hazard a second assertion, which is more disputable perhaps, to the effect that on or about December 1910 human character changed.

I am not saying that one went out, as one might into a garden, and there saw that a rose had flowered, or that a hen had laid an egg. The change was not sudden and definite like that. But a change there was, nevertheless; and since one must be arbitrary, let us date it about the year 1910. The first signs of it are recorded in the books of Samuel Butler,[2] in *The Way of All Flesh* in particular; the plays of Bernard Shaw[3] continue to record it. In life one can see the change, if I may use a homely illustration, in the character of one's cook. The Victorian cook lived like a leviathan in the lower depths, formidable, silent, obscure, inscrutable; the Georgian cook is a creature of sunshine and fresh air; in and out of the drawing room, now to borrow the *Daily Herald,* now to ask advice about a hat. Do you ask for more solemn instances of the power of the human race to change? ... All human relations have shifted—those between masters and servants, husbands

1 *Mr. Wells* H.G. Wells (1866-1946), author of many realistic novels as well as numerous works of science fiction; *Mr. Galsworthy* John Galsworthy (1867-1933), leading realistic dramatist and novelist, best known for *The Forsyte Saga*; *Edwardian* Relating to or characteristic of the reign of Edward VII (1901-1910); *Mr. Forster* E.M. Forster (1879-1970), fiction writer; *Mr. Lawrence* D.H. Lawrence (1885-1930), poet and novelist; *Mr. Strachey* Lytton Strachey (1880-1932), essayist; *Mr. Joyce* James Joyce (1882-1941), novelist and short story writer; *Mr. Eliot* T.S. Eliot (1888-1965). In the draft of this essay as it was delivered to the Cambridge Heretics Society, 18 May 1924, Woolf included two more names in this list—"Miss Sitwell, Miss Richardson"—referring to poet Edith Sitwell (1887-1964) and novelist Dorothy Richardson (1873-1957). *Georgians* Relating to or characteristic of the reign of George V, which had begun in 1910.

2 *Samuel Butler* Writer Samuel Butler (1835-1902), best known for his novel *The Way of All Flesh* (1903), a bitingly satirical vision of Victorian England, written between 1873 and 1885 but not published until after Butler had died.

3 *Bernard Shaw* Dramatist George Bernard Shaw (1856-1950).

and wives, parents and children. And when human relations change there is at the same time a change in religion, conduct, politics, and literature. Let us agree to place one of these changes about the year 1910.

I have said that people have to acquire a good deal of skill in character-reading if they are to live a single year of life without disaster. But it is the art of the young. In middle age and in old age the art is practised mostly for its uses, and friendships and other adventures and experiments in the art of reading character are seldom made. But novelists differ from the rest of the world because they do not cease to be interested in character when they have learnt enough about it for practical purposes. They go a step further; they feel that there is something permanently interesting in character in itself. When all the practical business of life has been discharged, there is something about people which continues to seem to them of overwhelming importance, in spite of the fact that it has no bearing whatever upon their happiness, comfort, or income. The study of character becomes to them an absorbing pursuit; to impart character an obsession. And this I find it very difficult to explain: what novelists mean when they talk about character, what the impulse is that urges them so powerfully every now and then to embody their view in writing.

… I am not going to deny that Mr. Bennett has some reason when he complains that our Georgian writers are unable to make us believe that our characters are real. I am forced to agree that they do not pour out three immortal masterpieces with Victorian regularity every autumn. But instead of being gloomy, I am sanguine. For this state of things is, I think, inevitable whenever from hoar old age or callow youth the convention ceases to be a means of communication between writer and reader, and becomes instead an obstacle and an impediment. At the present moment we are suffering, not from decay, but from having no code of manners which writers and readers accept as a prelude to the more exciting intercourse of friendship. The literary convention of the time is so artificial—you have to talk about the weather and nothing but the weather throughout the entire visit— that, naturally, the feeble are tempted to outrage, and the strong are led to destroy the very foundations and rules of literary society. Signs of this are everywhere apparent. Grammar is violated; syntax disinte- grated, as a boy staying with an aunt for the weekend rolls in the ge-

ranium bed out of sheer desperation as the solemnities of the sabbath wear on. The more adult writers do not, of course, indulge in such wanton exhibitions of spleen. Their sincerity is desperate, and their courage tremendous; it is only that they do not know which to use, a fork or their fingers. Thus, if you read Mr. Joyce and Mr. Eliot you will be struck by the indecency of the one, and the obscurity of the other. Mr. Joyce's indecency in *Ulysses* seems to me the conscious and calculated indecency of a desperate man who feels that in order to breathe he must break the windows. At moments, when the window is broken, he is magnificent. But what a waste of energy! And, after all, how dull indecency is, when it is not the overflowing of a superabundant energy or savagery, but the determined and public-spirited act of a man who needs fresh air! Again, with the obscurity of Mr. Eliot. I think that Mr. Eliot has written some of the loveliest lines in modern poetry. But how intolerant he is of the old usages and politenesses of society—respect for the weak, consideration for the dull! As I sun myself upon the intense and ravishing beauty of one of his lines, and reflect that I must make a dizzy and dangerous leap to the next, and so on from line to line, like an acrobat flying precariously from bar to bar, I cry out, I confess, for the old decorums, and envy the indolence of my ancestors who, instead of spinning madly through mid-air, dreamt quietly in the shade with a book. Again, in Mr. Strachey's books, *Eminent Victorians* and *Queen Victoria*,[1] the effort and strain of writing against the grain and current of the times is visible too. It is much less visible, of course, for not only is he dealing with facts, which are stubborn things, but he has fabricated, chiefly from eighteenth-century material, a very discreet code of manners of his own, which allows him to sit at table with the highest in the land and to say a great many things under cover of that exquisite apparel which, had they gone naked, would have been chased by the men-servants from the room. Still, if you compare *Eminent Victorians* with some of Lord Macaulay's[2] essays, though you will feel that Lord Macaulay is always wrong, and Mr. Strachey always right, you will also feel a body, a sweep, a richness in Lord Macaulay's essays which show that his age was behind him; all his strength went

1 *Eminent Victorians and Queen Victoria* Both books (published in 1918 and 1921, respectively) adopt an ironical or satirical tone in presenting a largely critical portrayal of the Victorian era.

2 *Macaulay* Thomas Babington Macaulay (1800–59), historian and essayist, known for shaping English history as a story of progress and improvement.

straight into his work; none was used for purposes of concealment or of conversion. But Mr. Strachey has had to open our eyes before he made us see; he has had to search out and sew together a very artful manner of speech; and the effort, beautifully though it is concealed, has robbed his work of some of the force that should have gone into it, and limited his scope.

For these reasons, then, we must reconcile ourselves to a season of failures and fragments. We must reflect that where so much strength is spent on finding a way of telling the truth the truth itself is bound to reach us in rather an exhausted and chaotic condition. Ulysses, Queen Victoria, Mr. Prufrock—to give Mrs. Brown some of the names she has made famous lately—is a little pale and dishevelled by the time her rescuers reach her. And it is the sound of their axes that we hear—a vigorous and stimulating sound in my ears—unless of course you wish to sleep, when in the bounty of his concern, Providence has provided a host of writers anxious and able to satisfy your needs.

Thus I have tried, at tedious length, I fear, to answer some of the questions which I began by asking. I have given an account of some of the difficulties which in my view beset the Georgian writer in all his forms. I have sought to excuse him. May I end by venturing to remind you of the duties and responsibilities that are yours as partners in this business of writing books, as companions in the railway carriage, as fellow travelers with Mrs. Brown? For she is just as visible to you who remain silent as to us who tell stories about her. In the course of your daily life this past week you have had far stranger and more interesting experiences than the one I have tried to describe. You have overheard scraps of talk that filled you with amazement. You have gone to bed at night bewildered by the complexity of your feelings. In one day thousands of ideas have coursed through your brains; thousands of emotions have met, collided, and disappeared in astonishing disorder. Nevertheless, you allow the writers to palm off upon you a version of all this, an image of Mrs. Brown, which has no likeness to that surprising apparition whatsoever. In your modesty you seem to consider that writers are of different blood and bone from yourselves; that they know more of Mrs. Brown than you do. Never was there a more fatal mistake. It is this division between reader and writer, this humility on your part, these professional airs and graces on ours, that corrupt and emasculate the books which should be the healthy

offspring of a close and equal alliance between us. Hence spring those sleek, smooth novels, those portentous and ridiculous biographies, that milk and watery criticism, those poems melodiously celebrating the innocence of roses and sheep which pass so plausibly for literature at the present time.

Your part is to insist that writers shall come down off their plinths and pedestals, and describe beautifully if possible, truthfully at any rate, our Mrs. Brown. You should insist that she is an old lady of unlimited capacity and infinite variety; capable of appearing in any place; wearing any dress; saying anything and doing heaven knows what. But the things she says and the things she does and her eyes and her nose and her speech and her silence have an overwhelming fascination, for she is, of course, the spirit we live by, life itself.

But do not expect just at present a complete and satisfactory presentment of her. Tolerate the spasmodic, the obscure, the fragmentary, the failure. Your help is invoked in a good cause. For I will make one final and surpassingly rash prediction—we are trembling on the verge of one of the great ages of English literature. But it can only be reached if we are determined never, never to desert Mrs. Brown....

Reactions to the Poems of T.S. Eliot

As the pieces excerpted below demonstrate, *Prufrock and Other Observations* was recognized as groundbreaking both by those who praised and by those who attacked it. Five years later *The Waste Land* provoked similar reactions. In *The Guardian* Charles Powell wrote that "the ordinary reader" would "make nothing of it," and complained that "meaning, plan, and intention alike are massed behind a smoke-screen of literary and anthropological erudition." To all except "anthropologists and *literati*," the poem was just "so much waste paper." In America the influential critic Louis Untermeyer savaged the poem as "a pompous parade of erudition ... a mingling of wilful obscurity and weak vaudeville." And *Time* (with reference to Joyce's *Ulysses* as well as to *The Waste Land*) reported that there was "a new kind of literature abroad in the land, whose only obvious fault is that no one can understand it." A significant number of early responses, however, were extraordinarily positive; two of these are excerpted below. Also excerpted is I.A.

Richards's influential 1926 discussion of the responses to and nature of Eliot's poetry.

from Arthur Waugh, "The New Poetry," *Quarterly Review* (October 1916)

Cleverness is, indeed, the pitfall of the New Poetry. There is no question about the ingenuity with which its varying moods are exploited, its elaborate symbolism evolved, and its sudden, disconcerting effects exploded upon the imagination. Swift, brilliant images break into the field of vision, scatter like rockets, and leave a trail of flying fire behind. But the general impression is momentary; there are moods and emotions, but no steady current of ideas behind them. Further, in their determination to surprise and even to puzzle at all costs, these young poets are continually forgetting that the first essence of poetry is beauty; and that, however much you may have observed the world around you, it is impossible to translate your observation into poetry, without the intervention of the spirit of beauty, controlling the vision, and reanimating the idea. The temptations of cleverness may be insistent, but its risks are equally great....

... Mr. Ezra Pound['s poetry is in effect] wooden prose, cut into battens:

Come, my songs, let us express our baser passions.
Let us express our envy for the man with a steady job and no
 worry about the future.
You are very idle, my songs,
I fear you will come to a bad end.
You stand about the streets. You loiter at the corners and bus-stops,
You do next to nothing at all.
You do not even express our inner nobility,
You will come to a very bad end.
And I? I have gone half cracked.

It is not for his audience to contradict the poet, who for once may be allowed to pronounce his own literary epitaph. But this, it is to be noted, is the "poetry" that was to say nothing that might not be said "actually in life—under emotion," the sort of emotion that settles down into the banality of a premature decrepitude:

I grow old ... grow old
I shall wear the bottoms of my trousers rolled.
Shall I part my hair behind? Do I dare to eat a peach?
I shall wear white flannel trousers, and walk upon the beach.
I have heard the mermaids singing, each to each.

I do not think that they will sing to me.

Here, surely, is the reduction to absurdity of that school of literary license which, beginning with the declaration "I knew my father well and he was a fool," naturally proceeds to the convenient assumption that everything which seemed wise and true to the father must inevitably be false and foolish to the son. Yet if the fruits of emancipation are to be recognised in the unmetrical, incoherent banalities of these literary "Cubists," the state of Poetry is indeed threatened with anarchy which will end in something worse even than "red ruin and the breaking up of laws." From such a catastrophe the humour, commonsense, and artistic judgment of the best of the new "Georgians" will assuredly save their generation; nevertheless, a hint of warning may not be altogether out of place. It was a classic custom in the family hall, when the feast was at its height, to display a drunken slave among the sons of the household, to the end that they, being ashamed at the ignominious folly of his gesticulations, might determine never to be tempted into such a pitiable condition themselves. The custom had its advantages; for the wisdom of the younger generation was found to be fostered more surely by a single example than by a world of homily and precept.

from Ezra Pound, "Drunken Helots[1] and Mr. Eliot," _The Egoist_ (June 1917)

Genius has I know not what peculiar property, its manifestations are various, but however diverse and dissimilar they may be, they have at least one property in common. It makes no difference in what art, in what mode, whether the most conservative, or the most ribbald-revolutionary, or the most diffident; if in any land, or upon any float-

1 _Helots_ Slaves. Pound alludes to Arthur Waugh's likening of the poetic displays of Eliot to the performances of a "drunken slave" (see above).

ing deck over the ocean, or upon some newly contrapted craft in the nether, genius manifests itself, at once some elderly gentleman has a flux of bile from his liver; at once from the throne or the easy Cowperian sofa,[1] or from the gutter, or from the economical press room there bursts a torrent of elderly words, splenetic, irrelevant, they form themselves instinctively into large phrases denouncing the inordinate product.

This peculiar kind of rabbia[2] might almost be taken as the test of a work of art; mere talent seems incapable of exciting it. "You can't fool me, sir, you're a scoundrel," bawls the testy old gentleman.

Fortunately the days when "that very fiery particle" could be crushed out by the *Quarterly* are over, but it interests me, as an archaeologist, to note that the firm which no longer produces Byron,[3] but rather memoirs, letters of the late Queen, etc., is still running a review, and that this review is still where it was in 1812, or whatever the year was; and that, not having an uneducated Keats[4] to condemn, a certain Mr. Waugh is scolding about Mr. Eliot.

All I can find out, by asking questions concerning Mr. Waugh, is that he is "a very old chap," "a reviewer." From internal evidence we deduce that he is, like the rest of his generation of English *gens-de-lettres*,[5] ignorant of Laforgue;[6] ... of his French contemporaries generally....

However, he outdoes himself, he calls Mr. Eliot a "drunken helot." So called they Anacreon[7] in the days of his predecessors, but from the context in the *Quarterly* article I judge that Mr. Waugh does not intend the phrase as a compliment, he is trying to be abusive, and moreover, he in his limited way has succeeded.

1 *Cowperian sofa* "The Sofa" (1785) is perhaps the best-known work by poet William Cowper (1731-1800).

2 *rabbia* Italian: rage.

3 *the firm which no longer produces Byron* The John Murray firm, which had been founded in the eighteenth century by John Murray (1745-93) and which in the early nineteenth century published the works of such distinguished writers as Lord Byron, Sir Walter Scott, and Robert Southey, also founded the *Quarterly Review* in 1809. At the time Pound was writing the John Murray publishing house remained an active book publisher, and still controlled the *Quarterly Review*, which had just published Waugh's article.

4 *Keats* John Keats (1795-1821), whose poetry had been attacked in the pages of the *Quarterly Review* a century earlier.

5 *gens-de-lettres* French: men of letters.

6 *Laforgue* Jules Laforgue (1860-87), French symbolist poet.

7 *Anacreon* Greek poet (c. 572 BCE-448 BCE), who wrote frequently of wine.

Let us sample the works of the last "Drunken Helot." ... I shall call my next anthology "Drunken Helots" if I can find a dozen poems written half so well as the following:

[Quotes from Eliot's poems "Conversation Galante" and "La Figlia che Piange"]

... Since when have helots made a new music, a new refinement, a new method of turning old phrases into new by their aptness? However, the *Quarterly*, the century old, the venerable ... has pronounced this author a helot. They are all for an aristocracy made up of, possibly, Tennyson, Southey and Wordsworth, the flunkey, the dull and the duller. Let us sup with the helots.

I confess [Waugh's] type of mind puzzles me, there is no telling what he is up to. I do not wish to misjudge him, his theory may be the correct one. You never can tell when old gentlemen grow facetious. He does not mention Mr. Eliot's name; he merely takes his lines and abuses them. The artful dodger, he didn't (*sotto voce* "he didn't want 'people' to know that Mr. Eliot was a poet"). The poem he chooses for malediction is the title poem, "Prufrock." It is too long to quote entire.

[Quotes "The Love Song of J. Alfred Prufrock": "For I have known them ... leaning out of windows"]

Let us leave the silly old Waugh. Mr. Eliot has made an advance on Browning. He has also made his dramatic personae contemporary and convincing. He has been an individual in his poems. I have read the contents of this book over and over, and with continued joy in the freshness, the humanity, the deep quiet culture. "I have tried to write of a few things that really have moved me" is so far as I know, the sum of Mr. Eliot's "poetic theory." His practice has been a distinctive cadence, a personal modus of arrangement, remote origins in Elizabethan English and in the modern French masters, neither origin being sufficiently apparent to affect the personal quality. It is writing without presence. Mr. Eliot at once takes rank with the five or six living poets whose English one can read with enjoyment.

The Egoist has published the best prose writer of my generation. It follows its publication of Joyce by the publication of a "new" poet

who is at least unsurpassed by any of his contemporaries, either of his own age or his elders.

It is perhaps "unenglish" to praise a poet whom one can read with enjoyment. Carlyle's generation wanted "improving" literature, Smile's *Self-Help*[1] and the rest of it. Mr. Waugh dates back to that generation, the virus is in his blood, he can't help it. The exactitude of the younger generation gets on his nerves, and so on and so on. He will "fall into line in time" like the rest of the bread-and-butter reviewers. Intelligent people will read "J. Alfred Prufrock"; they will wait with some eagerness for Mr. Eliot's further inspirations.

from an unsigned review, *Literary World* (5 July 1917)

Mr. Eliot is one of those clever young men who find it amusing to pull the leg of a sober reviewer. We can imagine his saying to his friends: "See me have a lark out of the old fogies who don't know a poem from a pea-shooter. I'll just put down the first thing that comes into my head, and call it 'The Love Song of J. Alfred Prufrock.' Of course it will be idiotic; but the fogies are sure to praise it, because when they don't understand a thing and yet cannot hold their tongues they find safety in praise." We once knew a clever musician who found a bois-terous delight in playing that pathetic melody "Only a Jew" in two keys at once. At first the effect was amusing in its complete idiocy, but we cannot imagine that our friend would have been so foolish as to print the score. Among a few friends the man of genius is privileged to make a fool of himself. He is usually careful not to do so outside an intimate circle. Mr. Eliot has not the wisdom of youth. If the "Love Song" is neither witty nor amusing, the other poems are interesting experiments in the bizarre and violent. The subjects of the poems, the imagery, the rhythms have the wilful outlandishness of the young revolutionary idea. We do not wish to appear patronising, but we are certain that Mr. Eliot could do finer work on traditional lines. With him it seems to be a case of missing the effect by too much cleverness. All beauty has in it an element of strangeness, but here the strangeness overbalances the beauty.

1 *Smile's Self-Help* The best known work of biographer Samuel Smiles (1812-1904), *Self-Help* (1882) laid out Smiles's theories on developing, educating, and improving the self. Its title became a catch phrase shortly after its publication.

from an unsigned review, *New Statesman* (18 August 1917)

Mr. Eliot may possibly give us the quintessence of twenty-first century poetry. Certainly much of what he writes is unrecognisable as poetry at present, but it is all decidedly amusing, and it is only fair to say that he does not call these pieces poems. He calls them "observations," and the description seems exact, for he has a keen eye as well as a sharp pen, and draws wittily whatever his capricious glance descends on. We do not pretend to follow the drift of "The Love Song of J. Alfred Prufrock." ...

from Conrad Aiken, "Diverse Realists," *Dial* (8 November 1917)

Mr. T.S. Eliot, whose book *Prufrock and Other Observations* is really hardly more than a pamphlet, is also a realist, but of a different sort. Like Mr. Gibson,[1] Mr. Eliot is a psychologist; but his intuitions are keener; his technique subtler. For the two semi-narrative psychological portraits which form the greater and better part of his book, "The Love song of J. Alfred Prufrock" and the "Portrait of a Lady," one can have little but praise. This is psychological realism, but in a highly subjective or introspective vein; whereas Mr. Gibson, for example, gives us, in the third person, the reactions of an individual to a situation which is largely external (an accident, let us say), Mr. Eliot gives us, in the first person, the reactions of an individual to a situation for which to a large extent his own character is responsible. Such work is more purely autobiographic than the other—the field is narrowed, and the terms are idiosyncratic (sometimes almost blindly so). The dangers of such work are obvious: one must be certain that one's mental character and idiom are sufficiently close to the norm to be comprehensible or significant. In this respect, Mr. Eliot is near the border-line. His temperament is peculiar, it is sometimes, as remarked heretofore, almost bafflingly peculiar, but on the whole it is the average hyper-aesthetic one with a good deal of introspective curiosity; it will puzzle many, it will delight a few. Mr. Eliot writes pungently and sharply, with an eye for unexpected and vivid details, and, particularly in the two longer poems and in the "Rhapsody on a Windy Night," he shows himself to be an exceptionally acute techni-

1 *Mr. Gibson* Poet Wilfred Gibson (1878-1962).

cian. Such free rhyme as this, with irregular line lengths, is difficult to write well, and Mr. Eliot does it well enough to make one wonder whether such a form is not what the adorers of free verse will eventually have to come to. In the rest of Mr. Eliot's volume one finds the piquant and the trivial in about equal proportions....

from May Sinclair, "*Prufrock and Other Observations*: A Criticism," *Little Review* (December 1917)

So far I have seen two and only two reviews of Mr. Eliot's poems: one by Ezra Pound in the *Egoist*, one by an anonymous writer in the *New Statesman*. I learn from Mr. Pound's review that there is a third, by Mr. Arthur Waugh, in the *Quarterly*. To Mr. Ezra Pound Mr. Eliot is a poet with genius as incontestable as the genius of Browning. To the anonymous one he is an insignificant phenomenon that may be appropriately disposed of among the Shorter Notices. To Mr. Waugh, quoted by Mr. Pound, he is a "drunken Helot." I do not know what Mr. Pound would say to the anonymous one, but I can imagine. Anyhow, to him the *Quarterly* reviewer is "the silly old Waugh." And that is enough for Mr. Pound. It ought to be enough for me. Of course I know that genius does inevitably provoke these outbursts of silliness. I know that Mr. Waugh is simply keeping up the good old manly traditions of the *Quarterly*.... And though the behaviour of the *New Statesman* puzzles me, since it has an editor who sometimes knows better, and really ought to have known better this time, still the *New Statesman* also can plead precedent. But when Mr. Waugh calls Mr. Eliot "a drunken Helot," it is clear that he thinks he is on the track of a tendency and is making a public example of Mr. Eliot....

I think it is something more than Mr. Eliot's genius that has terrified the *Quarterly* into exposing him in the full glare of publicity and the *New Statesman* into shoving him and his masterpieces away out of the public sight. For "The Love Song of J. Alfred Prufrock" and the "Portrait of a Lady" are masterpieces in the same sense and in the same degree as Browning's *Romances* and *Men and Women*....

But Mr. Eliot is dangerous. Mr. Eliot is associated with an unpopular movement and with unpopular people. His "Preludes" and his "Rhapsody" appeared in *Blast*. They stood out from the experimental violences of *Blast* with an air of tranquil and triumphant achievement; but, no matter; it was in *Blast* that they appeared. That

circumstance alone was disturbing to the comfortable respectability of Mr. Waugh and the *New Statesman*. And apart from this purely extraneous happening, Mr. Eliot's genius is in itself disturbing. It is elusive; it is difficult; it demands a distinct effort of attention. Comfortable and respectable people could see, in the first moment after dinner, what Mr. Henley and Mr. Robert Louis Stevenson and Mr. Rudyard Kipling[1] would be at; for the genius of these three travelled, comfortably and fairly respectably, along the great high roads. They could even, with a little boosting, follow Francis Thompson's[2] flight in mid-air, partly because it was signalled to them by the sound and shining of his wings, partly because Thompson had hitched himself securely to some well-known starry team. He was in the poetic tradition all right. People knew where they were with him, just as they know now where they are with Mr. Davies[3] and his fields and flowers and birds. But Mr. Eliot is not in any tradition at all, not even in Browning's and Henley's tradition. His resemblances to Browning and Henley are superficial. His difference is twofold; a difference of method and technique; a difference of sight and aim. He does not see anything between him and reality, and he makes straight for the reality he sees; he cuts all his corners and his curves; and this directness of method is startling and upsetting to comfortable, respectable people accustomed to going superfluously in and out of corners and carefully round curves. Unless you are prepared to follow with the same nimbleness and straightness you will never arrive with Mr. Eliot at his meaning.... He insists on your seeing, very vividly, as he sees them, the streets of his "Preludes" and his "Rhapsody." He insists on your smelling them.

... And these things are ugly. The comfortable mind turns away from them in disgust....

Instead of writing round and round about Prufrock, explaining that his tragedy is the tragedy of submerged passion, Mr. Eliot simply removes the covering from Prufrock's mind: Prufrock's mind, jumping quickly from actuality to memory and back again, like an animal,

1 *Mr. Henley* English poet and critic William Henley (1849-1903); *Robert Louis Stevenson* Scottish poet and novelist (1850-94); *Rudyard Kipling* English author born in Bombay (1865-1936).

2 *Francis Thompson* Poet known for his religious themes (1859-1907).

3 *Mr. Davies* Poet William Henry Davies (1871-1940), whose work often dealt with nature and the lives of the poor.

hunted, tormented, terribly and poignantly alive.… It is nothing to the *Quarterly* and to the *New Statesman* that Mr. Eliot should have done this thing. But it is a great deal to the few people who care for poetry and insist that it should concern itself with reality. With ideas, if you like, but ideas that are realities and not abstractions.…

from a review of the first issue of *The Criterion*, *The Times Literary Supplement* (26 October 1922)

Mr. Eliot's poem is also a collection of flashes, but there is no effect of heterogeneity, since all these flashes are relevant to the same thing and together give what seems to be a complete expression of this poet's vision of modern life. We have here range, depth, and beautiful expression. What more is necessary to a great poem? This vision is singularly complex and in all its labyrinths utterly sincere. It is the mystery of life that it shows two faces, and we know of no other modern poet who can more adequately and movingly reveal to us the inextricable tangle of the sordid and the beautiful that make up life. Life is neither hellish nor heavenly; it has a purgatorial quality. And since it is purgatory, deliverance is possible. Students of Mr. Eliot's work will find a new note, and a profoundly interesting one, in the latter part of this poem.…

from Gilbert Seldes, review, *The Nation* (6 December 1922)

In essence "The Waste Land" says something which is not new: that life has become barren and sterile, that man is withering, impotent, and without assurance that the waters which made the land fruitful will ever rise again. (I need not say that "thoughtful" as the poem is, it does not "express an idea"; it deals with emotions, and ends precisely in that significant emotion, inherent in the poem, which Mr. Eliot has described.) The title, the plan, and much of the symbolism of the poem, the author tells us in his "Notes," were suggested by Miss Weston's remarkable book on the Grail legend, *From Ritual to Romance*; it is only indispensable to know that there exists the legend of a king rendered impotent, and his country sterile, both awaiting deliverance by a knight on his way to seek the Grail; it is interesting to know further that this is part of the Life or Fertility mysteries; but the poem is self-contained. It seems at first sight remarkably discon-

nected, confused, the emotion seems to disengage itself in spite of the objects and events chosen by the poet as their vehicle. The poem begins with a memory of summer showers, gaiety, joyful and perilous escapades; a moment later someone else is saying "I will show you fear in a handful of dust," and this is followed by the first lines of "Tristan und Isolde," and then again by a fleeting recollection of loveliness. The symbolism of the poem is introduced by means of the Tarot pack of cards; quotations, precise or dislocated, occur; gradually one discovers a rhythm of alternation between the visionary (so to name the memories of the past) and the actual, between the spoken and the unspoken thought. There are scraps, fragments; then sustained episodes; the poem culminates with the juxtaposition of the highest types of Eastern and Western asceticism, by means of allusions to St. Augustine and Buddha; and ends with a sour commentary on the injunctions "Give, sympathize, control" of the Upanishads,[1] a commentary which reaches its conclusion in a pastiche recalling all that is despairing and disinherited in the memory of man.

A closer view of the poem does more than illuminate the difficulties; it reveals the hidden form of the work, indicates how each thing falls into place, and to the reader's surprise shows that the emotion which at first seemed to come in spite of the framework and the detail could not otherwise have been communicated. For the theme is not a distaste for life, nor is it a disillusion, a romantic pessimism of any kind. It is specifically concerned with the idea of the Waste Land—that the land *was* fruitful and now is not, that life had been rich, beautiful, assured, organized, lofty, and now is dragging itself out in a poverty-stricken, and disrupted and ugly tedium, without health, and with no consolation in morality; there may remain for the poet the labor of poetry, but in the poem there remain only "these fragments I have shored against my ruins"—the broken glimpses of what was. The poem is not an argument and I can only add, to be fair, that it contains no romantic idealization of the past; one feels simply that even in the cruelty and madness which have left their record in history and in art, there was an intensity of life, a germination and fruitfulness, which are now gone, and that even the creative imagination, even hallucination and vision have atrophied, so that water shall never again be struck from a rock in the desert. Mr. Bertrand Russell

1 *Upanishads* Mystical scriptures of Hinduism.

has recently said that since the Renaissance the clock of Europe has been running down; without the feeling that it was once wound up, without the contrasting emotions as one looks at the past and at the present, "The Waste Land" would be a different poem, and the problem of the poem would have been solved in another way....

It will be interesting for those who have knowledge of another great work of our time, Mr Joyce's "Ulysses," to think of the two together.[1] That "The Waste Land" is, in a sense, the inversion and the complement of "Ulysses" is at least tenable. We have in "Ulysses" the poet defeated, turning outward, savoring the ugliness which is no longer transmutable into beauty, and, in the end, homeless. We have in "The Waste Land" some indication of the inner life of such a poet. The contrast between the forms of these two works is not expressed in the recognition that one is among the longest and one among the shortest of works in its genre; the important thing is that in each the theme, once it is comprehended, is seen to have dictated the form. More important still, I fancy, is that each has expressed something of supreme relevance to our present life in the everlasting terms of art.

from I.A. Richards, *Principles of Literary Criticism* (1926)

Mr. Eliot's poetry has occasioned an unusual amount of irritated or enthusiastic bewilderment. The bewilderment has several sources. The most formidable is the unobtrusiveness, in some cases the absence, of any coherent intellectual thread upon which the items of the poem are strung. A reader of "Gerontion," of "Preludes," or of "The Waste Land," may, if he will, after repeated readings, introduce such a thread. Another reader after much effort may fail to contrive one. But in either case energy will have been misapplied. For the items are united by the accord, contrast, and interaction of their emotional effects, not by an intellectual scheme that analysis must work out. The value lies in the unified response which this interaction creates in the right reader. The only intellectual activity required takes place in the

1 *It will be interesting ... the two together* Ezra Pound may have been the first to make this comparison; when Pound was lobbying for the publication of *The Waste Land* in the United States, he wrote to Scofield Thayer, editor of *The Dial*, claiming that Eliot's "poem is as good in its way as *Ulysses* is in its way." Seldes was then Managing Editor of *The Dial*, in the pages of which *The Waste Land* was published on 20 October 1922 (four days after its first British publication, in the first issue of *The Criterion*).

realisation of the separate items. We can, of course, make a "rationalisation" of the whole experience, as we can of any experience. If we do, we are adding something which does not belong to the poem. Such a logical scheme is, at best, a scaffolding that vanishes when the poem is constructed. But we have so built into our nervous systems a demand for intellectual coherence, even in poetry, that we find a difficulty in doing without it.

This point may be misunderstood, for the charge most usually brought against Mr. Eliot's poetry is that it is overintellectualised. One reason for this is his use of allusion. A reader who in one short poem picks up allusions to *The Aspern Papers, Othello,* "A Toccata of Galuppi's," Marston, *The Phoenix and the Turtle, Antony and Cleopatra* (twice), "The Extasie," *Macbeth, The Merchant of Venice,* and Ruskin, feels that his wits are being unusually well exercised. He may easily leap to the conclusion that the basis of the poem is in wit also. But this would be a mistake. These things come in, not that the reader may be ingenious or admire the writer's erudition (this last accusation has tempted several critics to disgrace themselves), but for the sake of the emotional aura which they bring and the attitudes they incite. Allusion in Mr. Eliot's hands is a technical device for compression. "The Waste Land" is the equivalent in content to an epic. Without this device twelve books would have been needed. But these allusions and the notes in which some of them are elucidated have made many a petulant reader turn down his thumb at once. Such a reader has not begun to understand what it is all about.

This objection is connected with another, that of obscurity. To quote a recent pronouncement upon "The Waste Land" from Mr. Middleton Murry: "The reader is compelled, in the mere effort to understand, to adopt an attitude of intellectual suspicion, which makes impossible the communication of feeling. The work offends against the most elementary canon of good writing: that the immediate effect should be unambiguous." Consider first this "canon." What would happen, if we pressed it, to Shakespeare's greatest sonnets or to *Hamlet*? The truth is that very much of the best poetry is necessarily ambiguous in its immediate effect. Even the most careful and responsive reader must reread and do hard work before the poem forms itself clearly and unambiguously in his mind. An original poem, as much as a new branch of mathematics, compels the mind which receives it

to grow, and this takes time. Anyone who upon reflection asserts the contrary for his own case must be either a demigod or dishonest; probably Mr. Murray was in haste. His remarks show that he has failed in his attempt to read the poem, and they reveal, in part, the reason for his failure—namely, his own overintellectual approach. To read it successfully he would have to discontinue his present self-mystifications.

The critical question in all cases is whether the poem is worth the trouble it entails. For "The Waste Land" this is considerable. There is Miss Weston's *From Ritual to Romance* to read, and its "astral" trimmings to be discarded—they have nothing to do with Mr. Eliot's poem. There is Canto XXVI of the *Purgatorio* to be studied—the relevance of the close of that canto to the whole of Mr. Eliot's work must be insisted upon. It illuminates his persistent concern with sex, the problem of our generation, as religion was the problem of the last. There is the central position of Tiresias in the poem to be puzzled out—the cryptic form of the note which Mr. Eliot writes on this point is just a little tiresome. It is a way of underlining the fact that the poem is concerned with many aspects of the one fact of sex, a hint that is perhaps neither indispensable nor entirely successful.

When all this has been done by the reader, when the materials with which the words are to clothe themselves have been collected, the poem still remains to be read. And it is easy to fail in this undertaking. An "attitude of intellectual suspicion" must certainly be abandoned. But this is not difficult to those who still know how to give their feelings precedence to their thoughts, who can accept and unify an experience without trying to catch it in an intellectual net or to squeeze out a doctrine. One form of this attempt must be mentioned. Some, misled no doubt by its origin in a Mystery, have endeavoured to give the poem a symbolical reading. But its symbols are not mystical, but emotional. They stand, that is, not for ineffable objects, but for normal human experience. The poem, in fact, is radically naturalistic; only its compression makes it appear otherwise. And in this it probably comes nearer to the original Mystery which it perpetuates than transcendentalism does.

If it were desired to label in three words the most characteristic feature of Mr. Eliot's technique, this might be done by calling his poetry a "music of ideas." The ideas are of all kinds, abstract and concrete, general and particular, and, like the musician's phrases, they

are arranged, not that they may tell us something, but that their effects in us may combine into a coherent whole of feeling and attitude and produce a peculiar liberation of the will. They are there to be responded to, not to be pondered or worked out....

How this technique lends itself to misunderstandings we have seen. But many readers who have failed in the end to escape bewilderment have begun by finding on almost every line that Mr. Eliot has written—if we except certain youthful poems on American topics—that personal stamp which is the hardest thing for the craftsman to imitate and perhaps the most certain sign that the experience, good or bad, rendered in the poem is authentic. Only those unfortunate persons who are incapable of reading poetry can resist Mr. Eliot's rhythms. The poem as a whole may elude us while every fragment, as a fragment, comes victoriously home. It is difficult to believe that this is Mr. Eliot's fault rather than his reader's, because a parallel case of a poet who so constantly achieves the hardest part of his task and yet fails in the easier is not to be found. It is much more likely that we have been trying to put the fragments together on a wrong principle.

Another doubt has been expressed. Mr. Eliot repeats himself in two ways. The nightingale, Cleopatra's barge, the rats, and the smoky candle-end, recur and recur. Is this a sign of a poverty of inspiration? A more plausible explanation is that this repetition is in part a consequence of the technique above described, and in part something which many writers who are not accused of poverty also show. Shelley, with his rivers, towers, and stars, Conrad, Hardy, Walt Whitman, and Dostoevski spring to mind. When a writer has found a theme or image which fixes a point of relative stability in the drift of experience, it is not to be expected that he will avoid it. Such themes are a means of orientation. And it is quite true that the central process in all Mr. Eliot's best poems is the same; the conjunction of feelings which, though superficially opposed,—as squalor, for example, is opposed to grandeur,—yet tend as they develop to change places and even to unite. If they do not develop far enough the intention of the poet is missed. Mr. Eliot is neither sighing after vanished glories nor holding contemporary experience up to scorn.

Both bitterness and desolation are superficial aspects of his poetry. There are those who think that he merely takes his readers into the Waste Land and leaves them there, that in his last poem he confesses

his impotence to release the healing waters. The reply is that some readers find in his poetry not only a clearer, fuller realization of their plight, the plight of a whole generation, than they find elsewhere, but also through the very energies set free in that realization a return of the saving passion.

from Douglas LePan, "Personality of the Poet: Some Recollections of T.S. Eliot" (1979)

LePan (1915-98), a poet, academic, and civil servant living in London in the 1940s, was introduced to Eliot through a letter from fellow-Canadian Wyndham Lewis. The account excerpted below describes conversations during and after the Second World War in which Eliot spoke of the composition of *The Waste Land*, of writing generally, and of his relationship with Ezra Pound. The excerpt is taken from LePan's *Bright Glass of Memory: A Set of Four Memoirs.* (copyright © The Estate of Douglas LePan)

When I returned from Italy towards the end of the War in Europe and was once again a civilian on the staff of Canada House, we picked up where we had left off. But now our meetings were more varied. We still sometimes met for tea in his office. Other times, though, he came to have lunch with me at the Carlton Grill. This was at the corner of the Haymarket and Pall Mall, and was the only part of the old Carlton Hotel that had been allowed to stay open, the rest having been taken for government offices. I had quickly fallen into the habit of having lunch there more often than I should, partly because it was so close to Canada House, partly because I now had diplomatic allowances and was supposed to spend them on reasonably civilized entertainment, and partly because it served such excellent dry martinis—cold and strong, with plenty of gin and not too much vermouth in them. I was pleased to find that Eliot was as fond of dry martinis as I was, and we always had two or three of them before having lunch.

It was there, amid hovering waiters and white-aproned busboys and trolleys being trundled about with joints and sweets, in a milieu of wealthy businessmen and senior civil servants and women of fashion, that we had some of our most interesting conversations about how to write poetry. I was usually there first. But in a few minutes

Eliot would come in, looking tall and brisk and elegant. I was always faintly surprised by how worldly he looked in those surroundings, although more often than not our talk was far from worldly. It was there, I remember, that one day he gave me advice about cutting a poem. When you think you have finished a poem, he advised, look at it carefully to see what is best in it, always bearing in mind that those passages by themselves may convey everything you want to say. If they do, you can cut away all the rest and leave the poem much clearer and stronger. Or the best parts of the poem may need only slight additions to make them complete in themselves. Or they may only need to be linked by brief transitional passages. But always work towards highlighting what is best in the poem. In particular, he warned me against the danger of going on after the poem is really finished. Stop before yielding to the temptation of adding something unnecessary. I think it was at that point that I said that, for me at least, as great a temptation was to open with an unnecessary intro-duction. He agreed, but in a tone that suggested that for him it was a temptation he had completely outgrown. He did volunteer, though, that when he had first started writing reviews for the *Times Literary Supplement* he had been greatly impressed by some counsel given him by Desmond McCarthy,[1] who had advised him as a matter of routine always to strike out the first paragraph he had written so that the rest of the essay would stand out more sharply.

Naturally I don't remember the course or continuity of many of our conversations at the Carlton Grill. But something else I remember very vividly is his telling me one day at lunch that he wrote the last page of *The Waste Land* in an afternoon and hardly changed anything in it afterwards. It would have been too pedantic for me to have asked him what he meant by the last page of *The Waste Land*. Yet it is by no means clear. In none of the editions in print at that time is the last page a more or less self-contained unit which could plausibly have been written at a single sitting. Nor is that true of any of the manuscripts published much later by Valerie Eliot in her edition of the original drafts of the poem. All that is beyond question is that at least the last eleven lines of the poem, so heterogeneous, so strange, so learned, and yet so molten, were written in an afternoon and never afterwards al-

1 *Desmond McCarthy* Editor, literary critic, and member of the Bloomsbury Group (1877-1952).

tered. From the way Eliot spoke, I think it can also be safely added that, after all the trouble he had had with the poem, he took a kind of pride that the end of it was given to him so spontaneously and so quickly.

In speaking to me about cutting, Eliot didn't mention Ezra Pound, although what he was recommending was really a generalization to all poetry of what Pound had done for *The Waste Land*. But one afternoon when I was having tea with him in his office, he did speak to me at length about Pound in an entirely different connection. It was at a time when Pound's name was in all the newspapers as a result of his being charged with treason by the United States Government because of his support for Mussolini during the War; and Eliot was clearly in great distress over what had happened to his old friend. He said he had been going over in his own mind what in Pound's character and nature might have brought him to the point where he could be charged with treason. He was still deeply perplexed and uncertain. But he had come to some tentative conclusions. All his life Pound had been extremely generous to writers and artists, particularly to writers and artists who were still unknown. He couldn't think of a single genuine new talent whom Pound had failed to recognize, or had failed to help, if help were required. In cases like that, his generosity had been unfailing and tireless. There he couldn't be faulted. But, on the other hand, he had had very little simple human kindliness of the undiscriminating kind that could go out to charwomen and sales clerks as well as to artists, simply because of irreducible human obligation. There, as Eliot went over his memories of him, he seemed to be almost totally lacking—almost totally lacking in the common ties that are indispensable for holding a society together. Was it that lack that had led him into treason? He had one other lack, Eliot went on speculatively, that might have had something to do with his willingness to break the bonds of obligation to his own countrymen. It was an almost total lack of humour. Could that also have contributed to his downfall? So Eliot sat in obvious pain, sifting the possibilities, while I was unable to say a word about a problem that clearly came home to him with such intimacy and anguish. I never knew Eliot to speak with such passion and such open bewilderment as when he was speaking of what had happened to Ezra Pound.

T.S. Eliot and Anti-Semitism

Considerable controversy occurred in the latter years of the twentieth century over the issue of T.S. Eliot and anti-Semitism. The issue had been raised here and there during Eliot's lifetime: J.V. Healy raised the matter in correspondence with Eliot in 1940; a letter by George Orwell in 1948 reveals that some were then suggesting in conversation that Eliot was anti-Semitic, and so on. Orwell no doubt gave voice to a then-common view in dismissing the suggestion:

> It is nonsense what Fyvel said about Eliot being anti-Semitic. Of course you can find what would now be called anti-Semitic remarks in his early work, but who didn't say such things at that time? (Letter to Julian Symons, 29 October 1948)

That anti-Semitism was widespread in the 1910s and 1920s in both the USA and Britain is unquestionable, and to some extent Eliot's views were no doubt those of the majority at the time. But few published literary works displayed the consistency of association that one finds in Eliot's early poetry between what is Jewish and what is squalid and distasteful. Still, scholars did not begin to air the matter publicly until 1971, when the issue of anti-Semitism in Eliot's works was raised by a leading critic, George Steiner, in a letter to *The Listener*:

> The obstinate puzzle is Eliot's uglier touches tend to occur at the heart
> of very good poetry (which is *not* the case with Pound). One thinks of
> the notorious "the Jew squats on the window-sill ... Spawned in some
> estaminet of Antwerp" in "Gerontion"; of
> The rats are underneath the piles.
> The Jew is underneath the lot.
> in "Burbank with a Baedeker: Bleistein with a Cigar"; of
> Rachel nee Rabinovich
> tears at the grapes with murderous paws
> in "Sweeney among the Nightingales." (*The Listener*, 29 April 1971)

The question Steiner raised as to how the uglier touches in Eliot's work connected with the aesthetic quality of the whole is one that has continued to interest scholars and critics. In an important 1988 book, another leading scholar, Christopher Ricks, put forward an extended

analysis of the ways in which various forms of prejudice may have animated both Eliot's work itself and responses to it. Ricks begins his study with a look at prejudice against women; he notes how the critics had picked up on the latent elements of misogyny in two famous lines from "The Love Song of J. Alfred Prufrock":

> John Crowe Ransome [puts a] rhetorical question: "How could they ['the women'] have had any inkling of that glory which Michaelangelo had put into his marbles and his paintings?"
>
> Helen Gardner does not as a woman have any different sense of the women: "The absurdity of discussing his giant art, in high-pitched feminine voices, drifting through a drawing room, adds merely extra irony to the underlying sense of the lines."
>
> ... What none of the critics will own is how much their sense of the lines is incited by prejudice.... Grover Smith [writes that] "the women meanwhile are talking, no doubt tediously and ignorantly, of Michael-angelo." For all we know, as against suspect (perhaps justifiably, but still), the women could be talking as invaluably as [renowned art historian] Kenneth Clark. (*T.S. Eliot and Prejudice*, 10-11)

Ricks analyzes at length and with considerable subtlety the "uglier touches" in Eliot's poetry, noting how these are associative rather than unequivocally prejudicial or inciteful. A line such as "The Jew is underneath the lot," he comments, does not "come clean, since the effect of the article 'the Jew' is to disparage all Jews ... while nevertheless leaving open a bolt-hole for the disingenuous reply that a particular Jew only is meant" (35).

As Ricks pointed out, some of Eliot's other writings are at least as disturbing as the published poems. Particularly troubling are an unpublished poem, "Dirge," that was part of an early draft of *The Waste Land*, and a passage from *After Strange Gods*, a series of lectures given by Eliot in Virginia in 1933, and published in book form a year later. (Eliot never allowed the book to be reprinted.) In the passage Eliot is describing what he feels is to be striven for in a society that properly values tradition:

> The population should be homogenous.... What is still more important is unity of religious background; and reasons of race and religion combine to make any large number of free-thinking Jews undesirable.

There must be a proper balance between urban and rural, industrial and agricultural development. And a spirit of excessive tolerance is to be deprecated. (*After Strange Gods*, 20)

If Ricks's focus was primarily a literary one, that of Anthony Julius in his *T.S. Eliot, Anti-Semitism, and Literary Form* (1995) was more broadly social—and more clearly provocative. With his searing indictment both of the anti-Semitism of Eliot's age and its memorable expressions in Eliot's verse, Julius touched a raw nerve. Whereas Rick's criticisms are often elliptical, and his tone generally reserved, Julius is direct and unrelenting:

> "Women," "jews," and "negroes" are not interchangeable "aliens" in Eliot's work. They are, respectively, intimidating, sightless, and transparent; their deaths are respectively longed for, delighted in, and noted without emotion....
>
> ... However, this does not amount to an argument for suppression. I censure; I do not wish to censor.... Eliot's anti-Semitic poems are integral to his oeuvre, an oeuvre which is to be valued and preserved.... One can teach anti-Semitism from such texts; one can also teach poetry. One reads them, appalled, and impressed. (40)

Like Steiner a generation earlier, Julius concludes that Eliot is "able to place his anti-Semitism at the service of his art." A storm of controversy followed the publication of Julius's book, with many defending Julius but many others continuing to argue either that Eliot was not anti-Semitic or that anti-Semitism was irrelevant to his work. A further camp held that anti-Semitism was in fact a significant presence, but that the poetry succeeds despite such "uglier touches" rather than in any way because of them. Today there remains no consensus on these issues, but there can be no doubt that the controversy has left a mark; it is unlikely that extended discussion of Eliot's poetry will again be able to take place without any reference to this troubling issue.

From the Publisher

A name never says it all, but the word "Broadview" expresses a good deal of the philosophy behind our company. We are open to a broad range of academic approaches and political viewpoints. We pay attention to the broad impact book publishing and book printing has in the wider world; we began using recycled stock more than a decade ago, and for some years now we have used 100% recycled paper for most titles. Our publishing program is internationally oriented and broad-ranging. Our individual titles often appeal to a broad readership too; many are of interest as much to general readers as to academics and students.

Founded in 1985, Broadview remains a fully independent company owned by its shareholders—not an imprint or subsidiary of a larger multinational.

For the most accurate information on our books (including information on pricing, editions, and formats) please visit our website at www.broadviewpress.com. Our print books and ebooks are also available for sale on our site.

On the Broadview website we also offer several goods that are not books—among them the Broadview coffee mug, the Broadview beer stein (inscribed with a line from Geoffrey Chaucer's *Canterbury Tales*), the Broadview fridge magnets (your choice of philosophical or literary), and a range of T-shirts (made from combinations of hemp, bamboo, and/or high-quality pima cotton, with no child labor, sweatshop labor, or environmental degradation involved in their manufacture).

All these goods are available through the "merchandise" section of the Broadview website. When you buy Broadview goods you can support other goods too.

broadview press

www.broadviewpress.com